Victorian
LIVERPOOL

HUGH HOLLINGHURST

AMBERLEY

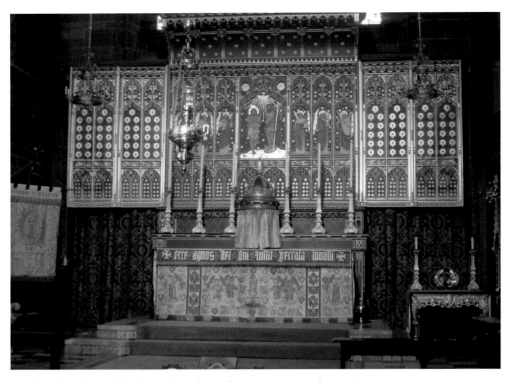

St John the Babtist Church, Tuebrook: exuberant Victorian decoration.

First published 2024

Amberley Publishing
The Hill, Stroud
Gloucestershire, GL5 4EP

www.amberleybooks.com

British Library Cataloguing in Publication Data.
A catalogue record for this book is available from the British Library.

ISBN 978 1 3981 1539 2 (paperback)
ISBN 978 1 3981 1540 8 (ebook)

Typeset in 10pt on 13pt Sabon.
Typesetting by SJmagic DESIGN SERVICES, India.
Printed in the UK.

Victorian
LIVERPOOL

CONTENTS

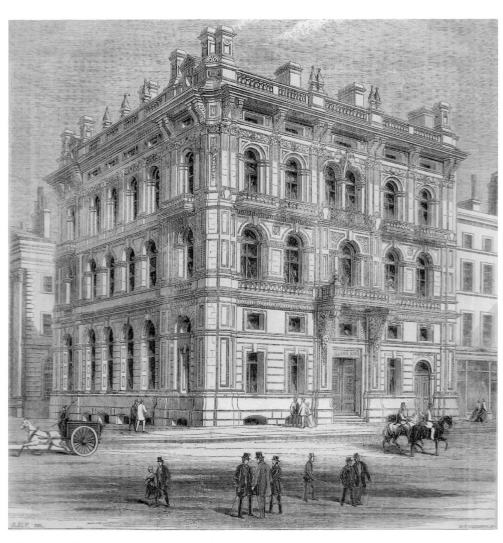

Alliance Bank: extravagant Victorian adornment.

ACKNOWLEDGEMENTS

To the following for illustrations:

John W Mellor Collection (courtesy Jane Mellor) pages 6, 11, 14, 15, 16, 20, 22, 29, 34, 49, 50, 52, 57, 62, 63, 67, 73(2), 77, 81(2), 92

Liverpool Record Office pages 17, 18, 19, 24, 43, 46, 48, 51, 66, 70, 76, 78, 79

Wikipedia Creative Commons pages 23, 24, 31, 32, 33, 37, 73, 77, 80, 86, 89, 91, 94, 95

Hugh/Paul Hollinghurst pages 4, 10, 13, 21, 25, 27(2), 28, 30, 35, 36, 37, 38, 39, 40, 41(2), 44, 45, 47, 53, 54, 55, 56(2), 59(2), 60, 61(2), 64, 65, 68, 69, 71, 75, 77, 80, 82(2), 84(2), 85, 87, 88, 89, 90, 91, 93, 96

Peter Owen page 12

Above all, I pay tribute as always to my wife Joan for her encouragement, support, patience and understanding

INTRODUCTION

When Queen Victoria came to the throne in 1837 Liverpool had just overtaken Bristol as the second port of the land. By the end of her reign, she proclaimed herself as second city of the Empire. With London and New York, she had become one of the three great maritime commercial centres of the world. England's industrial revolution was born in the north-west of the country. Liverpool, with its shipping and rail connections, was a vital link between the material resources and manufacturing capabilities of the region through to the rest of the country and the furthest corners of the globe. After the comparatively limited range of the previous century's slave trade to Africa and North America, Liverpool spread her sails to South America and beyond to China. In 1839, the first ship carrying the increasingly lucrative guano cargo arrived from South America, and sail gave way to steam. In 1838, the largest and first steamer to cross the Atlantic, the 1,150-ton *Great Liverpool*, took fourteen days after two attempts with fifty–sixty passengers. By the end of the century, regular services by the 12,950-ton luxury *Lucania* transported 2,000 passengers in five days. Within England, railway links spread rapidly to bolster trade and foster national interchange of culture and ideas. The opening of the Grand Junction Railway forged a direct link to London by 1838.

After the first British royal visit in 1846, by the end of Queen Victoria's reign Liverpool was honoured with over twenty more with many more foreign royal visitors. From a population base of 286,487 (including the suburbs) in 1841 there was a steady increase through the censuses to 617,032 in 1891. However, there were wild fluctuations and Liverpool became a boom town of newcomers with half of the population in 1861 born outside Lancashire. The population of 1847 doubled in one year largely due to immigration from Ireland because of famine. Health services were strained to the limit with 47,610 Irish 'paupers' on parish relief; 20,000 special constables were sworn in to combat unrest and repeated riots. Five years later there was a similar-sized drop in population of 300,000. During the same period shipping almost doubled. But Liverpool rose to the challenges with the appointment of a Public

Health Officer, the first such in the world, and a Dock Engineer who in fourteen years quadrupled the extent of the docks and protected them with walls that survive in all their glory to this day. The well-being of the port was promoted by a succession of leading citizens who funded and founded many charitable and educational institutions. In the process, Liverpool became increasingly confident to advertise itself through a host of breathtakingly beautiful and well-endowed public buildings and parks. The neo-Classical architecture of St George's Hall is acclaimed as the finest in the country, if not far beyond. Commercial companies vied to surpass each other in scale and style. Innovative educational institutions attracted an increasing number of students eager to advance themselves and the town. The docks were not only, essentially, useful but impressed visitors with their proud and imposing appearance. Religious toleration allied to heathy competition contributed to many outstandingly beautiful, glorious and well-endowed places of worship for Anglican, Catholic, non-Conformist and Jewish congregations. These and the many other remarkable buildings that have survived the blitz and developers admirably reflect the spirit of the age.

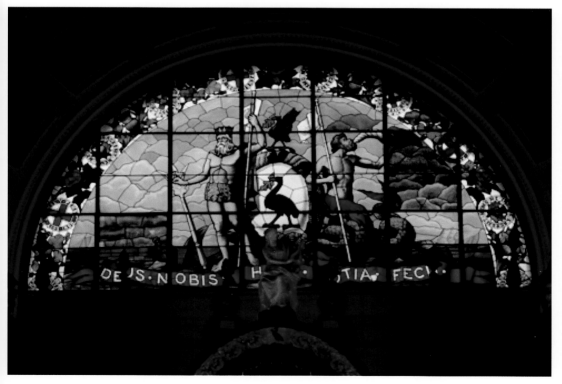

Liverpool coat of arms on window in St George's Hall.

1

PUBLIC
BUILDINGS

St George's Hall

St George's Hall is said to be the finest neo-Classical building in the world, certainly in Britain. It also embodies the aspirations of Liverpool at the very time when the town was embarking on the glories of the Victorian era. Indeed, the hall was mooted just before Victoria came to the throne in 1837 and funds were being raised as she was crowned. Designs were invited in an open competition which was won by a young architect, Harvey Lonsdale Elmes (son of architect James Elmes). When he also won a competition for law courts, it was decided to combine the two buildings and a concert hall was added later. The ensemble was opened to the accompaniment of Handel's

St George's Hall
with statue of Albert,
Prince Consort.

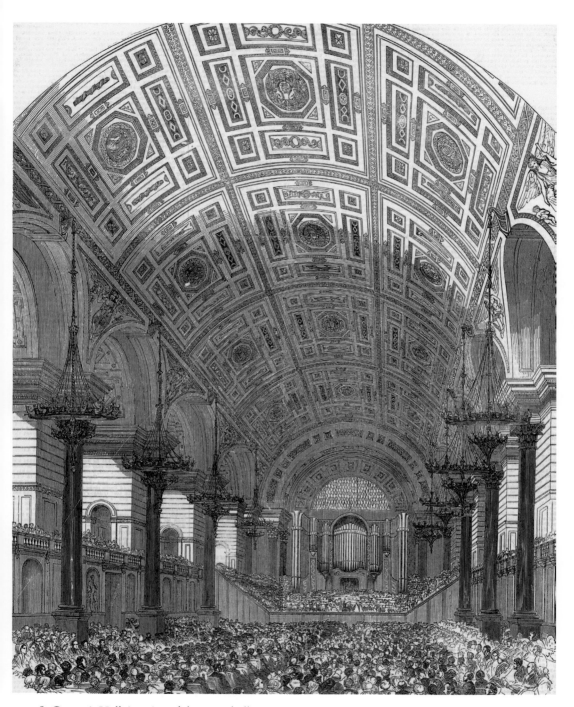

St George's Hall, interior of the great hall.

oratorio *Messiah* in 1854. As can be seen on the engraving of the event at the time, the ceiling is richly decorated with panels. They depict the coats of arms of Liverpool and Lancaster arranged in a pattern with the royal arms in the centre. The Liverpool coat of arms represented a Liver bird flanked by Mercury (Roman god of trade) and Neptune (god of the sea). They all appear separately on numerous buildings throughout the city and point to Liverpool's ambition to be thought of as capital of a new Roman empire. The great hall takes its inspiration from the Baths of Caracalla in Rome and this is reinforced throughout the hall by the letters SPQL, Latin for the 'Senate and people of Liverpool', adapted from the SPQR that the Romans used. The supports and lights of the splendid chandeliers are in the form of the prows of Roman warships. A window with the coat arms was added later over the organ at the far end (see page 9).

The floor, composed of over 30,000 Minton tiles, is still in perfect condition as it was covered over with a removable surface of wood to give Victorians the spring they needed to enjoy their dancing. The intricate design is centred on the royal coat of arms (in the centre). Mercury, Neptune, his companion Triton and Nereids, and Liverpool's coat of arms figure largely in the intricate design. All but one of the thirteen statues round the perimeter are of eminent Victorians with connections to Liverpool. They include (in the order the statues were sculpted): George Stephenson, engineer of the Liverpool and Manchester Railway; Sir William Brown, founder of the library; Revd Jonathan Brooks, inaugural Archdeacon of Liverpool; Joseph Mayer,

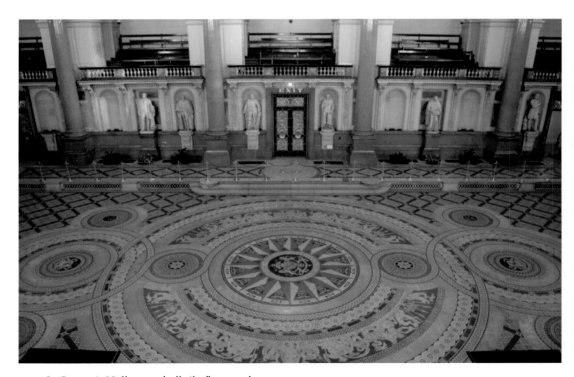

St George's Hall, great hall tile floor and statues.

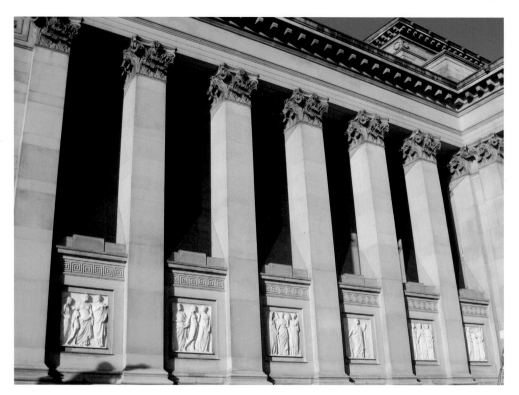

St George's Hall, exterior with panels of progress of Justice.

goldsmith, antiquary and collector; the 14th Earl of Derby, three times Prime Minister; William Ewart Gladstone, born in Liverpool, four times Prime Minister; Revd Hugh McNeile, controversial cleric; Samuel Robert Graves and Edward Whitley, Members of Parliament for Liverpool; the 16th Earl of Derby, politician; and Kitty Wilkinson, originator of baths and washhouses for the poor. She was the first woman and the first person to be honoured there for over a hundred years, in 2012.

The columns of the Greco-Roman exterior are designed in the Greek Corinthian order, their capitals flamboyantly decorated with acanthus leaves in the style the Romans preferred. The sculptures, which in a Greek temple appear in a frieze over the columns, are brought down to ground level so that they can be fully appreciated. These six panels depict a symbolic progress of Justice; another balancing set of six on the other side of the main entrance portray the progress of Liverpool. The Greek key pattern runs across over the panels and a dentil (teeth-like) decoration adorns the roof levels.

St George's Plateau

When St George's Hall was constructed, two columns of red granite were found to be surplus to requirements inside the hall. They were set up as seen on the plateau between

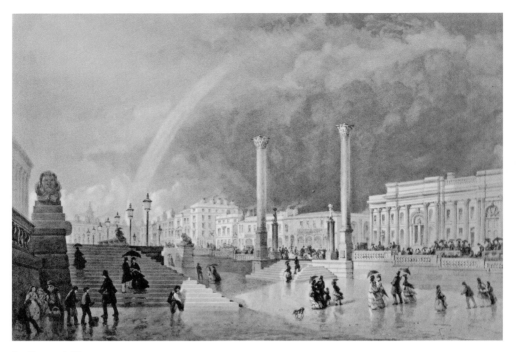

St George's Plateau.

the hall and the screen wall of Lime Street station. This had been built in Classical style and beautifully complemented the design of the hall. However, the columns, serving no useful purpose and looking so odd, were nicknamed 'candlesticks' and eventually removed. The drawing is by W. G. Herdman who had set out to preserve in print many of the Georgian buildings that were fast disappearing under Victorian developments. Here, however, he has depicted a contemporary atmospheric scene in 1857. It is a wild, rainy day but a break in the clouds accompanied by a rainbow has shed some light on the buildings, steps and figures. A row of street lights leads the eye to the steeple of Christ Church in the distance. Passengers on the upper deck of the horse-drawn buses passing the station, and pedestrians on the plateau, shelter under umbrellas. A stray dog and street sellers on the left complete the picture.

St John's Church and Gardens

St John's Church was built in 1783 on land known as the 'Great Heath', close to the Old Haymarket. When St George's Hall was built in the 1840s both buildings were close to each other and conflicted in styles. The church was Gothic with a tower out of proportion to its over-elaborate and ponderous nave and was labelled crude and ugly by other architects, while the hall displayed elegant Classical lines. St John's was also surrounded by a churchyard in which were interred 82,491 bodies before it was closed in 1865. A redevelopment plan (or architect's dream?!) as shown was drawn up

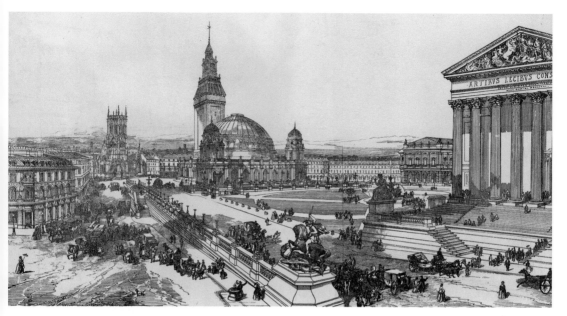

St John's Church redevelopment plan, 1854.

as early as 1854, the year St George's Hall (on the right) was officially opened. It shows a cathedral-like building with a Classical base, corner towers and dome while the top of the dominant centre tower and the church in the distance (which was also never built) are in Gothic style. This was favoured for churches in contrast to a Classical design for public buildings. The site was considered for the Anglican cathedral when it was mooted in the early 1880s, and in 1885 Parliament authorised the building of a cathedral on the spot. However, the site was considered too restrictive for the scale of the building and the project was not revived until 1900 when eventually St James' cemetery was chosen. In the meantime, the last service at St John's had been held in 1898, followed by demolition the next year. In 1904 the site was landscaped into 'St John's Ornamental and Memorial Gardens'.

Wellington Monument

Vast crowds are assembled on 16 May 1863 to witness the unveiling of the Wellington Monument. Spectators line the top of St George's Hall on the right and Lime Street station facade in the distance on the left. If actually so, doubtless there were others atop the Walker Art Gallery, behind to the right. This shows how the site had been carefully selected as the focal point for the developing public buildings on St George's Plateau. Although the Royal Standard waves over the hall, it was the Mayor of Liverpool who was presiding. The Duke had died in 1851 and the panels at the base of the statue depicting his triumphs were not finished until 1865. At the base of the monument to the left there are the remains of the building operations which were still

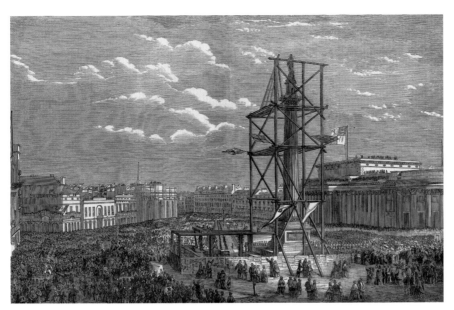

Wellington
Monument
unveiling.

incomplete. There were many causes for the delay: the money was slow to come in since Wellington was not as popular in Liverpool as the seafaring Nelson had been; two competitions were staged, one for the column and the other for the statue; it proved difficult to find and decide on the site, and subsidence was experienced during construction.

Exchange Buildings

Is this the most beautiful of the three Exchange Buildings? Initially the Exchange was combined with the Town Hall but separate buildings were built in a strict Classical style in 1803 to form exchange flags to the rear of the Town Hall. A newsroom was the hub of this enterprise with, in addition, both office and warehouse accommodation. However, by the mid-nineteenth century businesses were setting up warehouses nearer the docks and new commercial ventures were concentrating in the vicinity of the Exchange – hence a rebuild to provide simple offices and sales rooms with a newsroom. It was designed by T. S. Wyatt of the prolific architect family associated with Liverpool from the rebuilding of the Town Hall in 1795. The flowery French second empire style of Napoleon III ironically embraced the monument to Nelson. Characteristically, the architecture was eclectic, a mix of different periods: the important centre and corner towers were crowned by mansard roofs, with their sloped sides punctured by dormer windows; the windows were decorated with Classical columns; the solid arches were strongly Romanesque; the walls were studded with statues; and the triangular and rounded pediments infilled with decoration in baroque fashion. It followed the layout of its predecessor, also adopted by its uninspiring successor of 1939, with an entrance from Tithebarn Street at the centre of the U-shaped block. The people in the picture

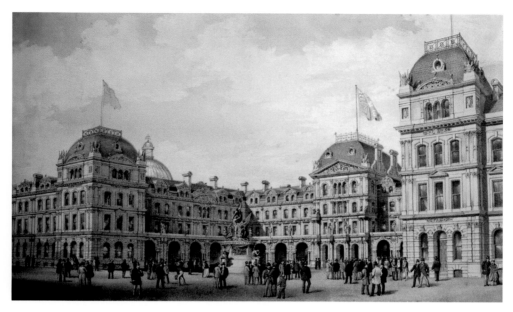

Exchange Buildings of 1864.

are an interesting commentary on the social status of women at the time. Only two are clearly visible amongst the great company of men: one to the far right, with neither her nor her partner participating in the main event, and the other in the distance sightseeing with her companion. One boy appears, centre stage!

Municipal Buildings

The Municipal Buildings are nearing completion in 1865. Only a three-tiered apex (with ridge-backed reptiles clinging to the top tier) leading to a pinnacle needs to be added to the clock tower. This will make it the highest building in Liverpool at 223 feet. It is the start of a line of superior, showy buildings that by the end of the century will stretch from here to the Town Hall, demolishing the attractive jumble of inferior premises to the right: Tho's Dodd, glass, oil and colourman, advertises his wares on the corner of Cumberland Street; next door, chemist Edwin Garland Heaton sports an attractive bow window; office workers at the Municipal will be glad to eat at Mary Archer's Commercial Dining Rooms during their lunch break or drink further on at the Eagle Vaults on the corner of Sir Thomas Buildings; in between, James Lind manufactures lamps. The 'Buildings' combined the work that had been done separately all over the town. The strongly Classical façade supports a French roof with some Gothic Revival detail. The capitals of the columns appear to be Corinthian with standard acanthus leaf decoration but are in fact English ferns, each of a different design. Above the capitals are symbolic figures sculpted in stone. On the main Dale Street facade, they represent the continents, agriculture, spinning, navigation, astronomy and commerce. The side

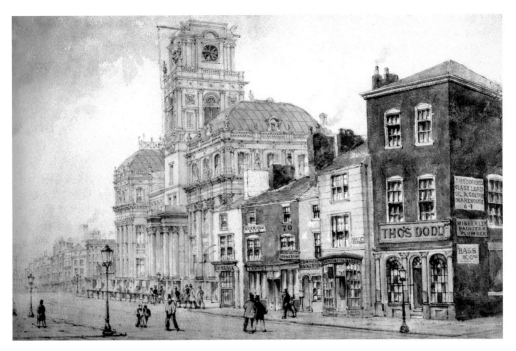

Municipal Buildings under construction, 1865.

street statues speak of industry, the arts, electricity and medicine. Liverpool is claiming that her commercial enterprise creates the country's prosperous civilisation.

Dale Street

A photographic view taken around 1900 illustrates the pace of change in building bigger and better along Dale Street. First in the field was Queens (immediate right), appropriately so named in the year of its construction in 1837 and designed in the traditional Classical style with double-height columns on the facade. It sports a distinctive sculptured royal coat of arms on its parapet in honour of Queen Victoria's accession. In the distance on the right is the tower of the Municipal Buildings now completed to its full height. The Georgian shops along the street which can be seen in the previous illustration were swept away by subsequent commercial buildings. The central dome tower of one of them, The Temple, also constructed in the 1860s, is visible in the photo. Hidden behind, the Gothic Prudential Assurance was sandwiched between it and the Municipal Buildings in 1886. Coming this way, the Royal Insurance Building is being built on the corner of North John Street. Liverpool was the first borough to be empowered to establish a tram network in 1868. Now, electricity has taken over from horses to propel the long line of open-top trams travelling towards the Pier Head, but horses still prance along at the head of cabs. Dwarfed by them all, one brave soul is sweating to push a cart on a sunny afternoon that encourages shopping underneath the canopies.

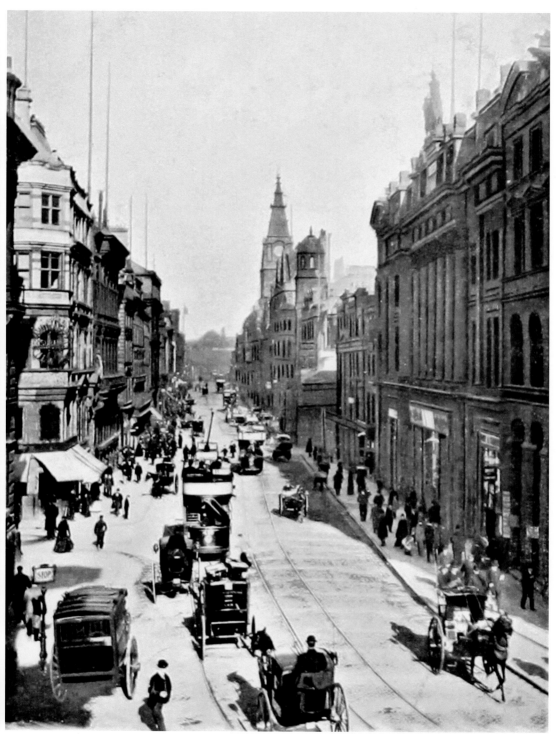

Dale Street around 1900.

County Sessions House

The County Sessions House is the most elaborately decorated of the Victorian public buildings along William Brown Street. The Lancashire coat of arms greets you in the pediment above the entrance; Composite columns combining the scrolls of the Ionic order and acanthus leaves of the Corinthian order top the columns, and images of Roman gods decorate the entablature above the windows. The magistrates heard cases involving non-capital offences, thus complementing the Crown Court of St George's Hall. The plan (top right) gives some idea of the complexities of design. Separate entrances and stairways ensured that the different categories of users did not meet until they reached one of the three courtrooms. The position and style of the entrances marked the status of the visitors. Magistrates and barristers entered the precinct through gates adorned with decorative lamps and ascended steps guarded by balustrades through to an impressive front door. The not-quite-so-grand side door that can be seen was for solicitors and witnesses. Members of the public used an ordinary door at the back. Prisoners were conducted through an iron gate on the opposite side. After the Quarter Sessions ceased, the building served as the Merseyside Museum of Labour History and is now used as offices.

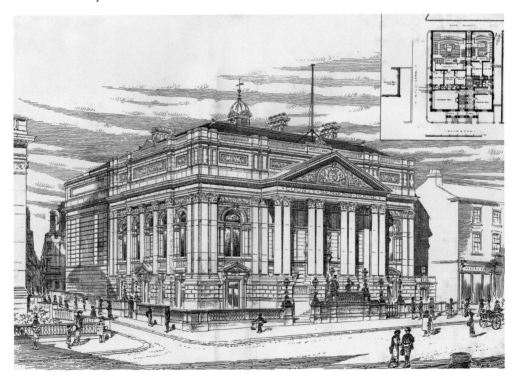

County Sessions House.

2
COMMERCE

Union Bank of Liverpool

Two Liver birds act in unison to pull tight a bundle of sticks. They represent, appropriately, the strength that comes from more than one strand working together as in the cables of a suspension bridge. This is the coat of arms of the Union Bank of Liverpool with their Latin motto 'vis unita fortior' (A United Force is Stronger). It appears on their former head office in Fenwick Street (as illustrated) and on their branch office in Bold Street. The Union Bank made several Liverpool acquisitions in the latter part of the nineteenth century and went on to take over Martins Bank in London and adopt its name, to be taken over eventually by Barclays. Liver birds appear scores of times on Liverpool buildings, rarely in tandem and usually just looking to the left

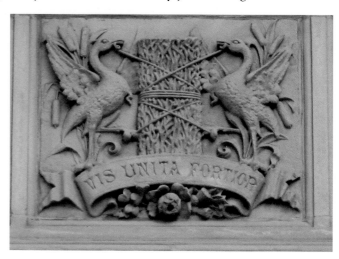

Union Bank of Liverpool coat of arms.

with a sprig of seaweed in their mouths. Their ancestry is contentious but they are most likely to be cormorants and are described as such on the coat of arms granted in 1797.

Bank of England

When the Bank of England opened its new branch building in Liverpool in 1847 it was important that it should look prestigious. The internationally renowned architect C. W. Cockerell, who had already been closely associated with Liverpool, was commissioned to design it. He had travelled with the Liverpool architect John Foster Junior to be acquainted personally with Classical architecture, in this case to Greece, as Italy was closed to the English for grand tours in the Napoleonic Wars. Foster had subsequently been responsible for many Greek Revival buildings in Liverpool and Cockerell had taken over from Elmes to complete the internal decoration of St George's Hall. His design is an amalgam of Greek, Roman and Renaissance elements. Double-storeyed Roman and Greek Doric columns make a strong impression on the facade. The bands on their capitals at the top are deferentially decorated with alternate English roses and Scottish thistles. The arched windows down the side with rusticated arches are Renaissance in style. The agent's residence at first-floor level has the use of balconies with iron railings. Cockerell also designed the lions on St George's Plateau. But he was not just a decorator. In constructing the Liverpool and London Insurance Offices he built in fireproofing. This was used elsewhere in the design of warehouses for merchants careful of their potential losses.

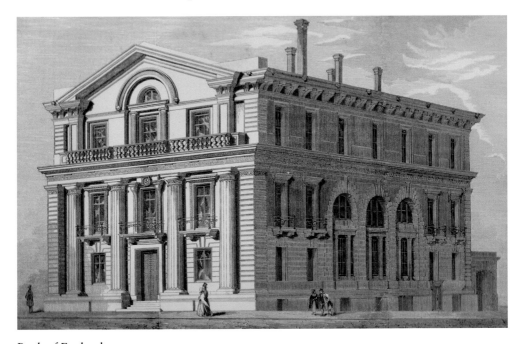

Bank of England.

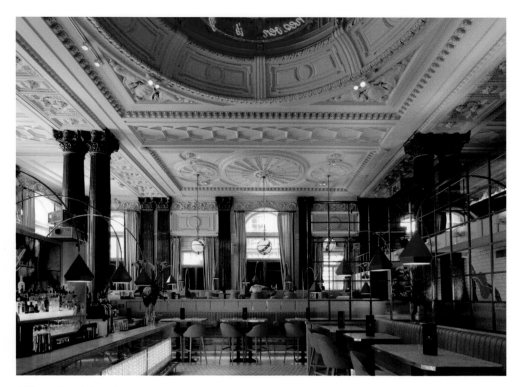

Alliance Bank interior.

Alliance Bank

Only twenty years separate the Bank of England from the Alliance Bank, opened in 1868, but its exterior is characterised by the elaborate and heavy decoration that increasingly dominated Victorian commercial buildings (see image on page 6). The aim, it seems, was to give investors the impression of security, a reassuring surplus of capital and superiority over their competitors. The matching extravagant ornamentation of the interior can be seen in a view of its conversion to hotel use.

Corn Exchange

Following the repeal of the Corn Laws in 1849 Liverpool merchants seized the opportunity for expanding their trade. The beautiful Corn Exchange that had been constructed in fine style as recently as 1807 was replaced by a magnificent new edifice designed by James Picton in 1851. As can be seen overpage, it was designed in appropriate restrained business-like style, untainted by over-elaborate Victorian ornamentation. Four storeys of offices faced Brunswick Street with two ranges of vaults underneath. The exchange proper consisted of a huge hall where the merchants could gather together centrally instead of inspecting the corn at multiple sites on the docks,

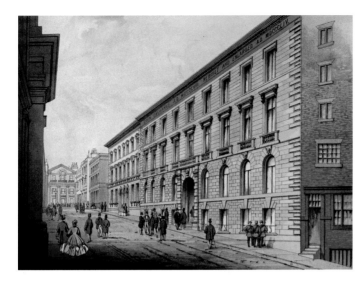

Corn Exchange looking
towards the Bank of
England.

and it could accommodate hundreds of merchants with tables for setting out samples. It was divided into three aisles by rows of columns with cast-iron arches supporting the roof. The well-lit boardroom on the third balconied storey was finely decorated with plasterwork ceiling and panelled walls but all was destroyed in the blitz of 1941.

The Albany

Flower drawing was a passion of the London architect J. K. Colling. Beautiful floral decoration can be seen from top to bottom of The Albany: underneath the eaves, over the windows, round the doorway and on and above keystones down to the basement windows. It was built speculatively in 1856 by banker and philanthropist Richard Naylor who had inherited a fortune from his uncle ten years before at the age of thirty-four. The huge building, occupying nearly a whole block, gives the impression of

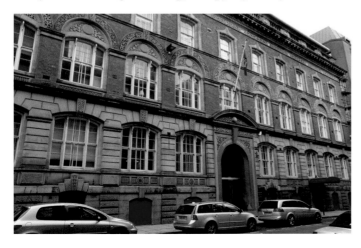

The Albany.

an Italian palazzo and encloses a courtyard. Ingeniously, two spiral staircases led to a bridge which connected the opposite sides at first-floor level; two top-glazed galleries down each side of the building provided additional day lighting. The building was a centre for cotton traders who used the top three storeys for segregated offices and storage. Cranes along the side elevation hoisted cotton bales to and from the main storage area in the basement. It has now been converted into apartments.

Oriel Chambers

What a contrast with The Albany (and any other contemporary building) only six years later! Peter Ellis was an architect way ahead of his time. It is still unbelievable that he could have designed Oriel Chambers in 1864. Oriel windows had been used in medieval buildings and became a Victorian favourite accessory as an aesthetic detail. However, Peter Ellis exploited its huge practical advantage of admitting extra lighting, and in this instance not just from the sides but the top. Additional full-frontal admittance of light was given by setting the windows in thin cast-iron framing separated by narrow stone piers. The Gothic cresting of these piers is the only reference to a traditional style while the cast-iron frame of the building and maximum use of glass makes it a Modernist icon. Ellis followed this up with an equally startling use of plate glass and narrow stone framing in his office block in Cook Street. Its rear courtyard has a unique glazed spiral staircase cantilevered from the wall. However, both designs were subjected to unfavourable criticism on aesthetic grounds. Maybe because of this Ellis concentrated on his engineering skills thereafter. However, it seems that through the strong links between Liverpool and the United States a visiting architect took Ellis's ideas across the Atlantic to be developed there.

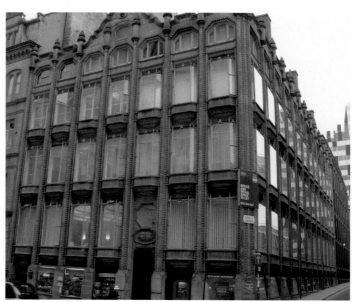

Oriel Chambers.

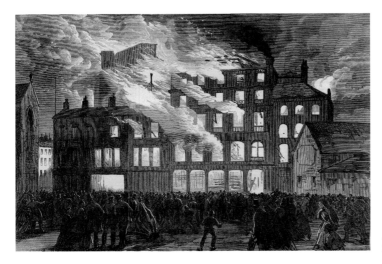

James Jeffrey's store on fire.

Compton House

Two young men opened a draper's shop in Church Street towards the beginning of the Victorian era. Their business prospered and by dint of adding shop after shop nearly filled the block bounded by Church Street, Tarlton Street, Basnett Street and Leigh Street. Disaster struck in 1865 when a fire started by a disgruntled apprentice destroyed the buildings. In the imaginative drawing of the scene the ramshackle nature of the premises can be seen. The corner of St Peter's Church, later the pro-cathedral, is on the left. However, James Jeffrey, now the sole owner of the business, rebuilt in grand French style, with thorough fireproofing and extensive workshops. Sleeping accommodation and recreational facilities were provided for live-in staff. At its reopening in 1867 as Compton House, it was an exceptionally early purpose-built department store anticipating and unequalled by the Bon Marche in Paris and any other in Europe. Unfortunately, the expenses of the new building were overwhelming and James Jeffrey was forced to close in 1871. It was converted into a hotel catering largely for Americans using transatlantic ships. As such it prospered, decorated by the eagles of America, until reverting to its original retail purpose as a Marks and Spencer store.

Ashcroft Buildings

Below the balcony of the Ashcroft Buildings in Victoria Street are a delightful set of ten panels carved in stone. They can hardly be seen by the naked eye and illustrate the profusion of unappreciated decoration on Victorian buildings. Representing Aesop's fables, the panels are, from left to right: the Wolf and the Lamb (illustrated), the Eagle and the Arrow, the Cocks and the Eagle, the Hare and the Tortoise, the Partridge and the Cocks, the Crow and the Pitcher, the Fox and the Goat, the Wolf and the Crane, the Lark and her Young, and the Cat and the Cock. The fourth floor contained workshops with a balcony from which some of the panels could be seen by the workers. Was it envisaged

that they would benefit from the morals of the fables? James Ashcroft, cabinetmaker and manufacturer of billiard tables, had set up business in 1865 and the buildings were completed in 1883. The roof, with an underlay of asphalt and concrete, could store 400 tons of timber and slate. One hundred tons of cast-iron was used in the structure to support the weight. An engine house on the third floor powered workshop machinery and hoist for materials. The corner turret housed apparatus to photograph all work of new and special designs. The family firm, now part of EA Clare and son, continued to the third generation and sponsored exhibition snooker matches in St George's Hall.

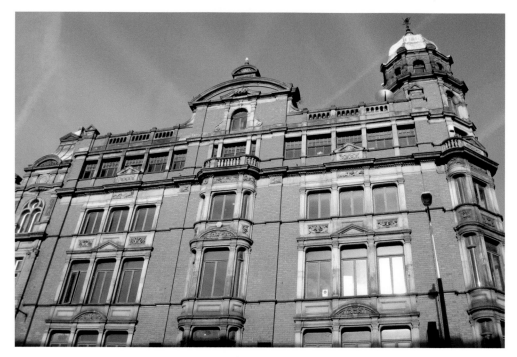

Above: Ashcroft Buildings.

Right: Aesop's fable of the Wolf and the Lamb.

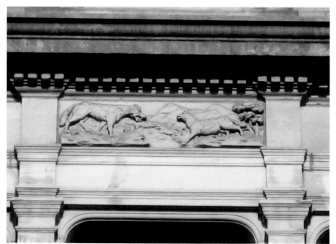

Dining Hall for Hartley's factory.

Hartley's Factory and Village

The proud proclamation 'Dining 1895 Hall' is above the windows of a beautiful building set at the heart of Hartley's factory and village. It shows the importance that jam maker William Pickles Hartley placed on the all-round well-being of his employees. Behind can be seen the tip of the tall chimney behind the huge engine house. To the left was situated the factory and to the right the main offices. Just over the road behind the viewer was the village set around a bowling green. William Hartley, a staunch Methodist, charged his workers extremely low rents for his houses and offered the better-off very favourable terms for buying them. A continuous service of boats from abroad brought produce into the docks which was transported from there by rail straight into the factory. At the height of the season the warehouses would be packed with fifteen million jars of jam and marmalade. William lived in an unpretentious house, now much better preserved than his factory. His village has been turned into a conservation area but too late, as can be seen, for the dining hall to be converted, and already defaced, for use as a warehouse.

Bold Street

A poster advertises Llamacloth paletot, a French outer coat made out of the wool of llamas or alpacas. They are pictured in pride of place top corners. Bottom corners feature the front of Dawbarn's, 110 Bold Street, who sponsored the poster, with well-dressed horse riders outside, a staid gentleman and adventurous lady. At the time Bold Street was Liverpool's upper-class equivalent of London's Bond Street.

A detail of the centrepiece shows St Luke's Church standing majestically at the top of the straight street, relic of a former ropery. Dawbarn's appears on the right with the royal coat of arms above the window. Its plain facade is outshone but artistically enhanced by a grander neighbour. The aura is increased by a carriage drawn up outside and gentlemen riding by on horseback. Ladies parade their bustles but dogs scrap in

the road. The text on the poster extols the advantages of shopping there in fulsome terms. It is 'the most beautiful part of the town, the most fashionable promenade and the most attractive place of business'. Dawbarn's prosperity 'may be attributed not alone to the reasonableness of their prices nor to their elegant & fashionable garments nor to the variety & choice selection of their stock but also to the adoption of that felicitous & satisfactory system of business – prompt cash payments'.

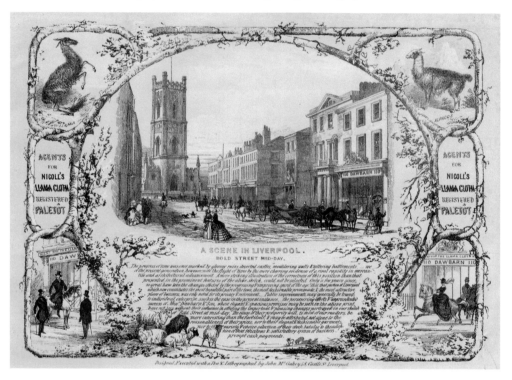

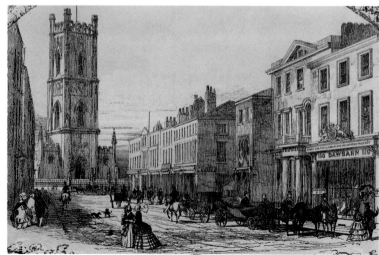

Above: Poster advertising Bold Street at midday.

Right: Detail of poster featuring Dawbarn's.

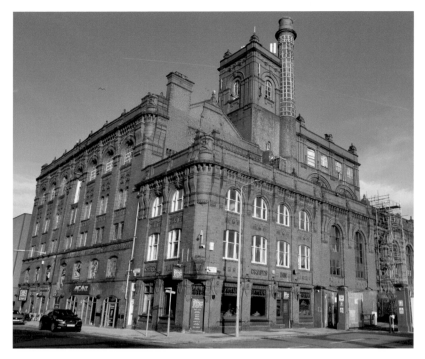

Cain's Brewery.

Cain's Brewery

The brewery is a perfect example of Victorian social mobility, possible above all in Liverpool. Robert Cain was born in poverty in County Cork, Ireland, in 1826, son of a private soldier in the British army. When his father left the army because of ill health, his parents took him as a baby to Liverpool to find work, where he grew up in poor circumstances in the Islington area. After experience in the dangerous West African trade in palm oil which had replaced slaves, and serving indentures, he married the daughter of a shoemaker. Together with her and their eleven children, he prospered as a cooper and brewer. He became respected and influential through his great wealth, philanthropy and political activities. His motto was 'pacem amo' (Latin for 'I love peace') which appeared on his pubs (see page 84), and the brewery illustrated. Hidden behind the chimney and tower is the original three-storey building with clock and inscription 1887. The fine facade of the five-storey building to the left was completed in 1902 together with the lower 'Grapes Inn' (now 'The Brewery Tap') on the corner.

Albion House

When this, the headquarters of the White Star Line, was completed in 1898, its height and distinctive red and white stripes commanded the attention of incoming ships. As a forerunner of the giant office blocks of the next century, it stood out in lonely

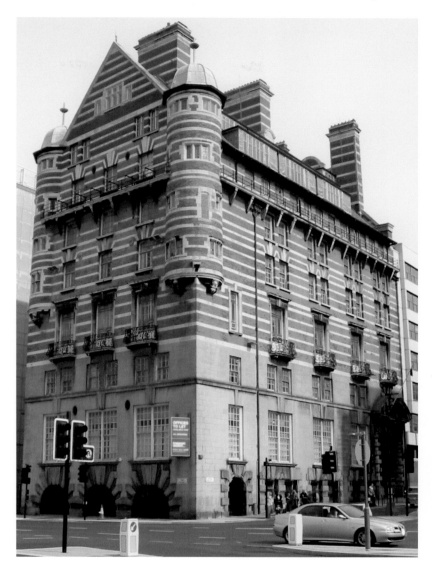

Albion House.

isolation. Within twenty years, however, it was upstaged and its view of the river and from the river blocked by the 'three graces', which included the headquarters of its great rival, Cunard. Norman Shaw, the architect of Albion House, had designed New Scotland Yard in London to which the Liverpool building bears a marked resemblance. It and the company must have gained much prestige from this, and the decoration of the stonework was more ornate, particularly of the gable at the top which has unfortunately been rebuilt in a simpler form after bomb damage. The balconies with their ornate railings on the second floor are typical of those that, often largely for show, indicated the boardroom. Inside, visitors are greeted by a fine mosaic floor in the entrance lobby but the general manager's office was severely functional. The building is now converted into apartments.

Royal Insurance Building

Conceived in the Victorian era and perfected in the Edwardian era, the Royal Insurance Building made a huge statement when it was completed in 1903. From the time that the company was founded in 1850 Liverpool was the second most important insurance centre after London. The assessor for the competition for the design was Norman Shaw of New Scotland Yard fame who awarded it (anonymously!?) to his friend Francis Doyle. Shaw subsequently collaborated with Doyle and was responsible for the pioneering internal steel frame. The materials were also of the best quality. Aberdeen granite formed rustic arches at ground level, enclosing windows for offices. Portland stone faced the floor above, which sported balconies and the superior windows of the boardroom on the Dale Street facade. The main entrance is on North John Street, a side street leading off Dale Street. Here, an extravagantly embellished doorway is paired with an equally decorated window above. From these emerge a tower adorned with a sundial rising through further ornamentation to a dome that catches the eye with its glittering gold on copper plates. Corner towers strengthen the Dale Street facade with tiny windows that draw attention to the larger ones at their level. Meaningful sculptural decoration on Victorian buildings is significant, in this case outstanding. The window above the entrance in North John Street is surmounted by a curved broken pediment which encloses a group of statuary representing Royalty, Honour, Plenty and Justice. On the floor above, a panel blatantly advertises 'The Direct and Indirect Results of Life Insurance' with figures of Invention and a fireman with an infant in his arms while a mother leans on his shoulder for support.

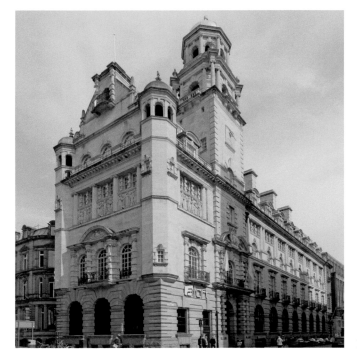

Royal Insurance Building.

More elaborate and altruistic is a triptych group round the corner in Dale Street as illustrated. Unfortunately, the ensemble cannot, like most public sculpture, be fully appreciated as it is set on the third floor. However, it does have a magnificent setting. Below is the curved pediment above the central window of the boardroom filled with decorative design. Above, it is framed by a frieze with bold dental (tooth-like) decoration. Ionic columns with their scroll decoration unite the sculptural panels with the row of windows above. These are separated by contrasting plainer columns with alternate round and square blocks typical of the Baroque style. The figures are highly symbolic. At the centre is Mercury, Roman messenger god of commerce, recognisable by his winged helmet. On each side of him two young women, representing the Powers of Nature, pour water to extinguish the fire of a burning world. This produces Plenty, symbolised by two putti who each bear a cornucopia (horn of plenty). The panel to the left shows the Sciences which develop the businesses that rely on insurance. They all bear an attribute to identify them individually, from the left: Engineering (steamship), Electricity (generator), Biology (skeleton), Chemistry (condenser) and Mathematics (globe and compasses). The panel to the right represents the Arts, whose losses can be replaced by insurance. Recognisable by their attributes, they are from left to right: Music (violin), Drama (masks), Painting (palette) and Architecture (Winged Victory and Greek temple). The architect pictured there bears the unmistakeable features of the architect of the building itself, James Francis Doyle! The company is now part of the Royal and Sun Alliance Insurance Group with the redundant building converted into a hotel.

Royal Insurance Building sculptural decoration.

3

SHIPPING

Landing Stage

The launch of the George's landing stage is being given an enthusiastic welcome in 1847. At 500 feet long and 89 feet wide, it was supported on iron pontoons and was eventually lengthened to 2,500 feet, capable of accommodating the largest Atlantic liners. Here, it is accompanied by paddle steamers just making their appearance before

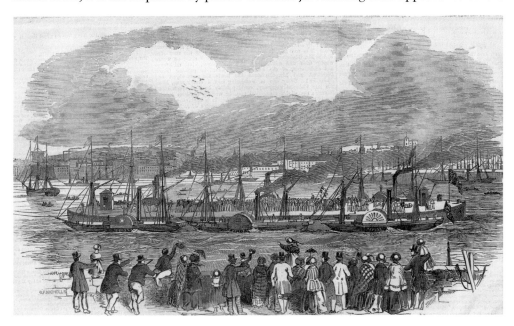

Launch of the floating landing stage.

screw propellors took over. As can be seen, the river was crowded with boats, but the artist has not depicted them in detail. Besides the sailing ships plying to distant parts there would be numerous smaller cargo boats and ferries, with an admixture of rowing boats if the artist is to be believed. A contemporary foreign visitor describes how 'At certain hours of the day, about twelve of these ferry steamers assemble at the same wharf to take in their several cargoes, and at a given signal they all start, scattering themselves across the Mersey like a pack of cards over a table.' He goes on to describe his ferry trip across the Mersey from Birkenhead in the dark: 'Every moment the echo of the noise made by our paddles as they struck the water, announced we were passing some stately vessel lying at anchor. These echoes increased in number as we proceeded and traversing a forest of masts … we speedily reached our landing place.'

Albert Dock

The Albert Dock was Jesse Hartley's first single major project, and his biggest. It was the first of the South Docks to be designed with warehouses as an integral part of the scheme. It meant that goods could be unloaded directly from the ships into a bonded warehouse and stay there until they could conveniently be transported onwards to their destination. Previously, goods were left on the quay by casual labour, which invited pilfering and entailed supervision to prevent it. Direct labour engaged by the Dock Trustees meant secure unloading was now possible. Excisemen could examine the goods at leisure in a warehouse instead of during a hasty visit on board, if they were available at the time. Provision was made for cranes to discharge cargo from the ships straight into the warehouse and transfer it onwards to carts and barges, thus saving repetitious handling. Fireproofing was a high priority. Experiments were carried out to produce the best results for the columns supporting the arcades. Wood was eliminated and cast iron chosen instead of granite because it showed a saving of

Albert Dock
with Liver
Building in the
distance.

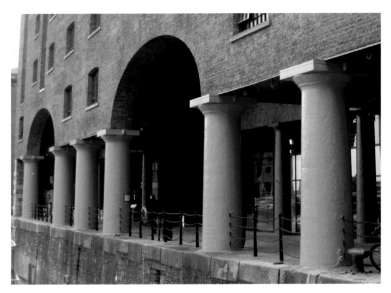

Albert Dock, iron column supports.

2 per cent (!). The striking bright red columns were given a further Classical touch by rings at the top of the columns and a square 'abacus' bearing the weight of the arch, which are a distinctive feature of the Doric order of Greek architecture. The appearance was perfected by the use of entasis employed in the finest example of that order on the Parthenon in Athens whereby the columns have a slight convex curve to their side to avoid the optical illusion of a concave line. Brick pillars inside the iron columns supported the brick arches. The hollow columns were set into a chase in the 2-foot-thick granite borders to the quay edge.

Work on the dock started in 1841 and continued 24/7 except for a break for a few hours after midnight on Sunday. It was opened by stages from 1845. Appropriately, Prince Consort Albert opened the dock officially the following year. The year after that a revolutionary hydraulic system, the first in the world, was installed to work the cranes. Unfortunately, the dock was designed for sailing ships and its use suffered a decline along with theirs, long before it was closed in 1972. However, its architectural and technical importance was amply recognised for it to be redeveloped and become one of the most visited tourist centres in the country.

Dock Traffic Office

The Dock Traffic Office was constructed in 1848 close to the Albert Dock, a few years after its completion. It was originally designed by Philip Hardwick and the portico bears a strong resemblance to the ill-fated Euston Arch with which he adorned the entrance to the terminus of the London and Birmingham Railway. Its construction was a tour de force of the latest medium already employed in the dock: cast iron. The 17-foot-high columns were cast in two halves and then welded together. Even more remarkably, the architrave over the columns is a single casting of 36 feet with embellishments welded

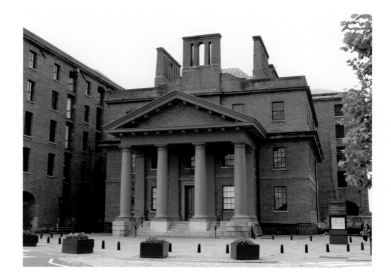

Dock Traffic Office.

onto it too. The columns, in the Roman Tuscan style, are slenderer and more decorous compared with the sturdy, plain Greek Doric of the Albert Dock. Hardwick's original two storeys were strengthened in appearance by Jesse Hartley who added a third for the principal clerk. It was accompanied in 1852 by a more homely building for the Pier Master and his family. He was expected to be on duty twenty-four hours a day and take immediate action whatever the time of day or night. The office has been taken over by Granada television and the house by the Liverpool Maritime Museum whose main site occupies the nearby wing of the Albert Dock.

Sandon Dock

Jesse Hartley's dock walls are his biggest construction. Extending for 2 miles, they kept goods safely inside before being taken away by their rightful owners and they deterred thieves from getting in. Gate piers reinforced their forbidding appearance and they

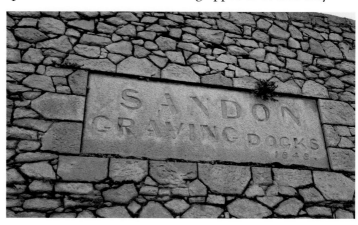

Sandon Dock.

clearly demarcated points of legitimate entry and exit with sliding gates. The close-up of Jesse Hartley's granite rubble wall reveals a significant date in his massive expansion of the dock system between 1844 and 1858 during which eight docks were built. No fewer than five were opened simultaneously in 1848 including Sandon as illustrated. Jesse, a Yorkshireman, was appointed Dock Surveyor in 1824 and during his time the docks expanded from 45 acres to over 210. Such an increase was not seen over the next seventy-year period until the Gladstone Dock was completed. Each dock played its part in the system as a whole with particular attention to the use of locks and half-tide basins to maintain the water level and ensure safety for the ships at all stages of the tide. He made an immediate impact drawing up a master plan in eight months and managed a wide range of responsibilities with one principal clerk in his office and an elderly inefficient storekeeper. He was demanding and irascible but energetic and industrious, ready to take on new ideas and make them work. He thought of himself as an engineer, surveyor and architect, displaying ingenious and idiosyncratic artistry.

Victoria Tower

The Victoria Tower could only have been designed by Jesse Hartley as it proudly displays 1848, his annus mirabilis. It stands at the entrance of Salisbury Dock to commemorate its opening together with Collingwood and Stanley Docks, trio companions. Proudly

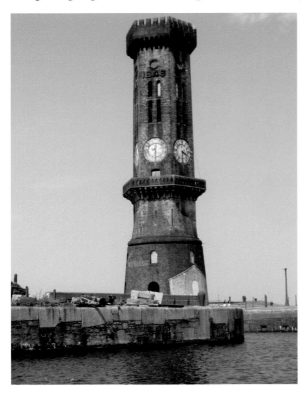

Victoria Tower.

proclaiming the strength of the docks like a fortress, it was also useful for sailors: a circular drum supports a hexagonal bell tower with a six-faced clock and lookout balcony. Stepped corbels support the balcony and battlements (which also top Jesse's hydraulic towers and harbour master's lodge). The machicolations there, and on the balcony, are typical of him. With a facing of random granite rubble, they also align well to give an air of defensive medieval fortification and therefore security.

Stanley Dock

The gates of Jesse Hartley's docks varied in design, suitable for the entrance to a stately home (on the left) or to a medieval castle (in the distance). Beyond the bridge to the right is a castellated hydraulic tower with attached chimney. The detached higher brick chimney is post-Victorian, as also the bascule bridge of the 1930s. A pair of simplified gate piers of lesser importance is on the right. These straddle a road entrance to the dock precinct which was bounded by a pair of warehouses. The end of one of them is visible on the far right of the photo. The other, now the Titanic Hotel, is hidden by the gigantic tobacco warehouse which was built later and dwarfs them both. At the time of construction in 1901 this gargantuan structure was claimed to be the largest brick building in the world (it is now being converted into 500 apartments). Stanley Dock is the only inland dock, not reclaimed from the river, which it accessed through the Collingwood and Salisbury Docks. It was conceived as a transport hub where ships, barges and railway wagons could meet. A branch from the Leeds Liverpool Canal led down through four locks to the dock, and rail connections ran through to the warehouses which were designed for hydraulic power. The gates of the bottom

Stanley Dock
warehouses.

Stanley Dock canal entrance.

lock where the canal enters the dock is pictured above. Note the massive granite blocks characteristic of Hartley's construction. Typically, he had opened a quarry in Kirkcudbrightshire and commissioned a purpose-built coaster to transport the granite, which cut costs dramatically. Two of the 117 brick arches of a viaduct over a mile long can be seen beyond. This completed the line from Bury into Exchange station in 1846. One remarkable arch in the final stretch (still standing) spanned around 100 feet with millions of bricks. This is the line from which a goods branch was constructed leading to a terminus at North Docks station in 1855 and connected with Stanley Dock. It enabled goods to be transferred from the dock onto train wagons that could use the burgeoning main line railway network. Connections had already been made with Manchester (via the first intercity line in the world in 1830), Birmingham (1837), London (1838) and Birkenhead and Chester (1840).

Wapping Dock Warehouse

Jesse Hartley first established intercommunication between different modes of transport in Wapping Dock. Railway links were made from there to the Wapping goods terminus of the Liverpool and Manchester Railway. Horse drawn at first, it was the beginning of the dock railway system which eventually stretched to the far end of the dock system and totalled 80 miles of track. Hartley continued his policy, already adopted in the Albert Dock, of setting the warehouse up against the water's edge. This, along with the outer walls of the dock estate, much reduced pilfering. It also meant that the goods could be loaded safely and undamaged straight from the ships into the warehouse or by crane to the upper storeys with help from hydraulic power from the outset. The handsome accumulator hydraulic tower on the right is typical of Hartley. Accumulators supplied constant high power needed to work the capstans, gates, locks and cargo handling at a time when steam was increasingly taking over from sail. The warehouse has now been converted into apartments. The columns of another bay that had to be demolished after bomb damage can be seen nearest the camera.

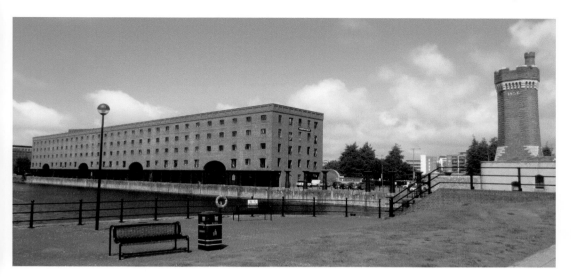

Wapping Dock Warehouse.

Waterloo Dock Warehouse

Waterloo Dock Warehouse was the first of a new breed in Liverpool, specialising in a particular commodity, in this case grain. On the repeal of the Corn Laws, the Harbour Board had foreseen the importance of trade with North America and the importation of its grain, reconstructing the dock as the first in the word to handle it in bulk. Completed in 1865, the warehouse is post-Hartley and shows it. G. F. Lyster, his successor in warehouse design, had, like Hartley, persuaded the financiers to incorporate extra expensive embellishment but expressed it differently. At dockside level, stone dressings line the arches with incised columns topped with a weighty square abacus at the top. The windows, rounded in pairs, rest on string courses and

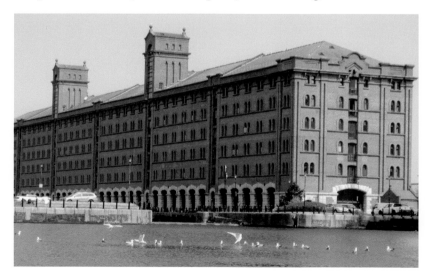

Waterloo Dock
Warehouse.

the turrets which house hoisting machinery flaunt mini Greek temples with baubles on the top. The loading bays (and corners) are emphasised by giant pilasters stretching right to the top and culminating with a dandy pediment surmounted by a Dutch gable. Even the attic storey is incorporated into a pseudo-Classical frieze. It was as if it had been designed on purpose for being converted into the present prestigious luxury apartments! G. F. Lyster took over from Hartley as dock engineer and together with his son A. G. Lyster, who succeeded him, added around 100 acres of area to the docks.

Emigrants

Great George Square and the surrounding streets specialised in the care of emigrants. Here, they are leaving their lodgings located in a Georgian terrace in the square. The two charabancs are packed (as the hotel must have been) with emigrants on their way to board the Cunard Line ship *Lucania*. It was launched in 1893 and many others plied the route to the United States with which the port was well placed and traditionally connected. The Lucania was the latest in technology and opulence. Her triple expansion engines were the acme of the type. The decoration was a feast of styles. Although the Art Nouveau fashion predominated at the time, the legendary first-class dining room sported Italian design. Joint largest ship in the world and holder of the Blue Riband, she carried 600 first-class passengers. Those pictured would have been some of the thousand third class. First class would have stayed in the Adelphi Hotel before embarking, or, after 1895 when the Riverside station was opened, transferred straight from the London train onto the ship. The photo is carefully posed: the heads of the horses that are drawing the second carriage are turned towards the camera. It demonstrates the momentousness of an occasion in the lives of hundreds of thousands of emigrants who have passed through the port.

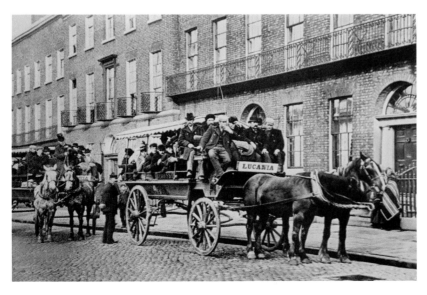

Great George Square emigrants leaving their boarding house.

4
RAILWAYS

Exchange Station

Described when opened in 1850 as a 'handsome piece of architecture', this is the original Exchange station on Tithebarn Street. As can be seen, your luggage might be carried by a porter on his head and then up a steep stairway to the entrance. Alternatively, a carriage could take you up inclined ramps to one side or the other. It was in fact

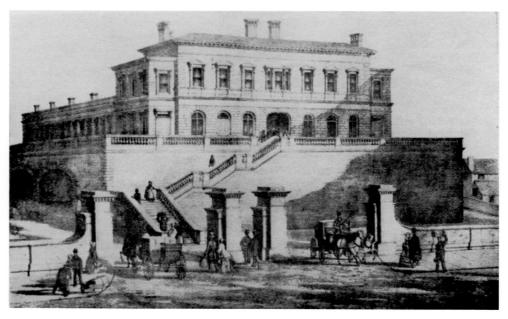

Exchange station of 1850.

two stations side by side. To break the monopoly in the area of the Liverpool and Manchester Railway (opened in 1830), two companies were formed. The Lancashire and Yorkshire Railway occupied the left-hand half, en route to Wigan, Bolton, Bury and Leeds, while the East Lancashire Railway on the right transported you to Preston and beyond. They were joined by the Liverpool, Crosby and Southport Railway in 1855. The elevated position of the station (90 feet up) was caused by the approach lines having to clear the Leeds Liverpool Canal. Contrast the tunnel which led into its rival's Lime Street station. The buildings contained waiting and refreshment rooms. In 1888 it was replaced on a lower level by a station with ten platforms, instead of the original four, fronted by a hotel. When the station was closed in 1977, the hotel was converted into business accommodation and the station platform area into a car park.

Lime Street Station

The passenger terminus of the Liverpool and Manchester Railway, first 'intercity' service in the world, was originally in Crown Street on the edge of the town. Six years later, a new line was constructed through a series of tunnels to a more central terminus in Lime Street. This was fronted by a fine Classical facade which matched St George's Hall on the other side of the Plateau (see page 14). In 1851 a new train shed was constructed, the largest in the world and the first to be made entirely of iron. The phenomenal growth of railway traffic over forty years forced a third station on the site with, for a time, the widest span in the country, completed in 1879. It is one of the great Victorian monumental engineering achievements, and beautiful too: sturdy red Doric columns shoulder intricate iron lattice work supporting a translucent roof that sweeps round in a graceful curve. The facade was then enhanced by the North Western Hotel designed by Alfred Waterhouse. It was veneered fittingly in grey stone instead of his trademark red brick. This was in deference to St George's Hall and its surrounding civic buildings, but its spiky and romantic silhouette contrasts with their Classical forms.

Lime Street station of 1879.

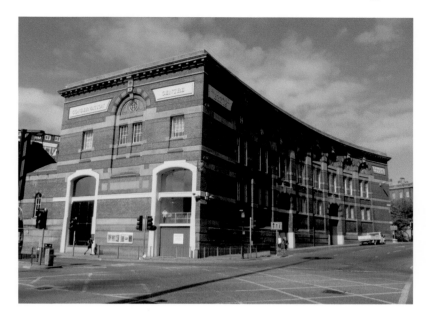

Midland Railway
Warehouse.

Railway Midland Goods

What a pleasant change not to have a box-like warehouse! The gentle, sloping curve was dictated by the site but must have caused difficulties for compact storage. The Midland Railway was just one of the railway companies of the time that went to huge expense to burrow their way into a terminal in the docks to tap into the lucrative freight traffic. Here, in 1874, the always progressive Midland extended their customer services to the heart of the town. In this storage centre, goods could be consigned and stored for onward transportation by cart to the appropriate railway station. The doorways for the ingress of goods are wide and high and the handsome appearance is good publicity for the railway. The cornice below the roof displays dentil decoration (in the form of teeth) and the ornamental arches over the windows are picked out in contrasting colours. Giant pilasters along the side form a base to the arches at the top (and over the doorways) with patterning of brick and stone. A rustic stone base gives the impression of solidity. It has been preserved as a Conservation Centre for the National Galleries and Museums on Merseyside.

Overhead Railway

By the middle of the eighteenth century the problem of getting goods and workmen to and from the docks was becoming acute. The idea of an overhead railway to alleviate the problem was born and reached fruition in 1893. Carrying passengers from one end of the docks to the other, it left the ground level freer for the transportation of cargo by rail and road at ground level. The railway was the first overhead railway line to be worked by electricity and the first to be fitted with automatic signalling. The

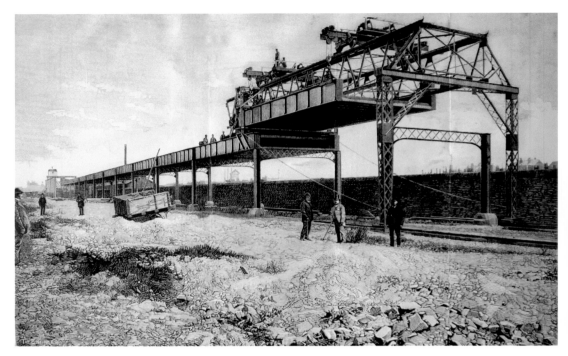

Overhead Railway construction gantry.

photograph shows the unique system of construction that was devised. Prefabricated sections were moved into position on the track already in place and then hoisted forward by means of temporary supports on rails onto permanent gantries ready to receive them. For much of its original 5-mile length it ran alongside the dock wall. The line was soon extended to tap into the tourist trade by connections at each end and became a popular way of viewing the ships, warehouses and activities of the docks.

Dock Railways

This scene could almost be in the Victorian era. Saddle tank locomotive No. 1 of the Mersey Docks and Harbour Board (MDHB), built in 1904 and now preserved, pulls some wagons from rail yards and heads for the Alexandra Dock. Running coal bunker first gives the driver a better view as it crosses the Dock Road to join the main dock line running underneath the Overhead Railway. A spark arrester fitted to its chimney avoids setting wood pulp or timber alight. Unfortunately, it will not prevent the exhaust from corroding the structure of the Overhead Railway as it runs underneath 'the dockers' umbrella' which was forced to close in 1956. The network at one time provided an essential link between the twelve railway goods yards and thirty-four docks along its length but was phased out when containerisation took over.

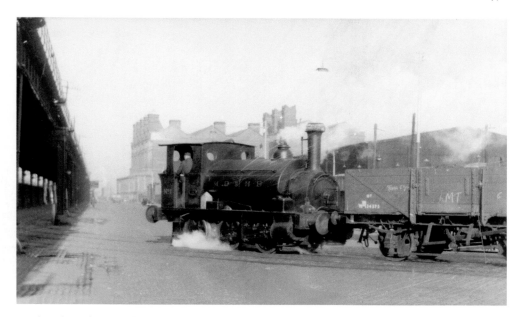

Dock railway line at Alexandra Dock.

Mersey Railway

Seepage difficulties were soon encountered when work on the first tunnel under the Mersey started in 1879 and, to extract the water, steam engines were housed in this pumping station. The system, powered now by electricity, has operated continuously and successfully from that day to this. The seepage water flowed down to the lowest part of the tunnel and was then drained through a separate bore to a level below the station. From there it was pumped to the surface and recycled into the river. There was

Mersey Railway
pumping station.

a third bore for ventilation. The importance of the railway was demonstrated by the Prince of Wales performing the opening ceremony accompanied by two of his sons in January 1886. The biting wind and snow did not dampen the enthusiasm of thousands of spectators and will have been a good advertisement for avoiding a stormy crossing on the ferry and travelling instead by comfort on the train. However, this was not without inconvenience. The ventilation tunnel could not cope with the choking exhaust from the steam locomotives and the number of travellers and the takings declined. Profitability was restored by an extension from James Street to Liverpool Central low level in 1892, electrification in 1903 and incorporation into the Merseyrail network in 1977.

Riverside Station

The first passenger train has just arrived at Riverside station on 12 June 1899. The mostly first-class travellers have boarded the train at London Euston station and are being greeted by a reception of high-ranking uniformed staff in honour of the occasion. Now they will walk straight onto a liner for their transatlantic voyage with porters taking their luggage to their cabins. They have been spared the previous tiresome double transit: having arrived at Lime Street station they would have stayed at the Adelphi Hotel for the night and from there taken a carriage ride to the Pier Head. This time, the train has departed from the main line at Edge Hill, descended through tunnels for freight traffic to the Waterloo Goods Depot and negotiated the newly constructed link to Riverside. It has been easy for the crews of the double or triple header to coast down through tunnels totalling over 2 miles in length but it will be near asphyxiating for them in the open cabs as the locomotives pound their way back up the steep gradient.

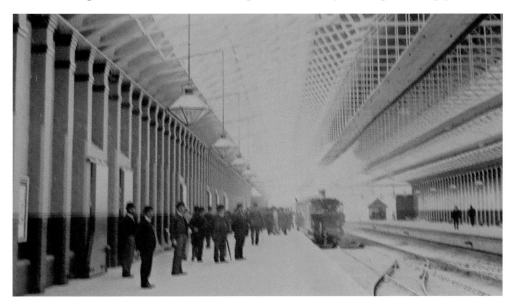

Riverside station.

5
CULTURE

Liverpool Collegiate Institution

The Collegiate Institution aimed to compete with the old established public schools. It was designed by Harvey Lonsdale Elmes, architect of St George's Hall, but in a completely different mode. Indeed, its High Tudor Gothic style reflected the appearance of Oxford and Cambridge colleges. Lord Stanley, 14th Earl of Derby and a scientist

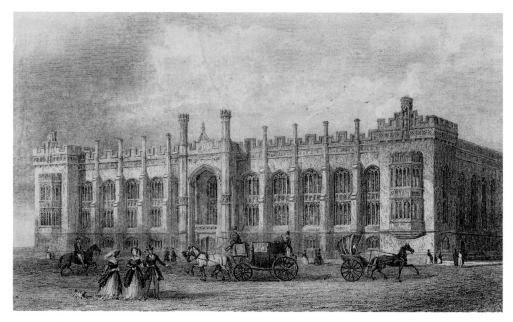

Liverpool Collegiate Institution.

ahead of his time, proclaimed in his speech after laying the foundation stone in 1840 that science 'was considered a monopoly of the rich, the high, the learned and the powerful' and should be opened up for all to learn. There should also be instruction useful for the middle, trading and working population. Overall, the education should be based on the Christian principles of the Established Church. This aim was reiterated by William Ewart Gladstone, four times Prime Minister, when he opened the school three years later, saying that it was for the benefit of the middle classes to which he belonged (though he went to Eton!). In fact, the building was divided into three separate schools, each with its own entrance: Lower (Commercial), Middle and Upper (who used the main central staircase and might go on to university). It was in essence truly comprehensive. In the picture, the conveyances and people give the impression of superiority, but in 1884 the Upper School migrated to new premises to become Liverpool College. The school was taken over by the Local Authority in 1904, closed in 1987 and converted by Urban Splash into apartments.

Kirkdale Industrial School

Until the early nineteenth century Kirkdale was a village surrounded by agricultural land. Then in 1819 a County House of Correction, otherwise known as Kirkdale Gaol, was built in glorious isolation in the countryside together with a Sessions House which was conveniently adjacent so that convicted criminals could start their sentence

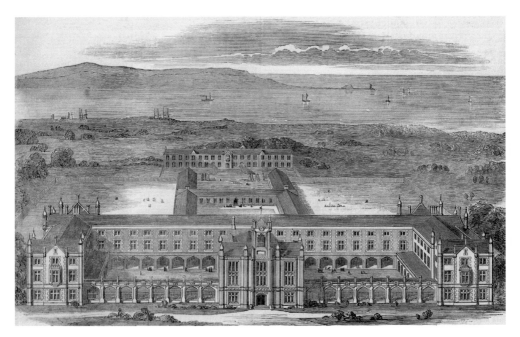

Kirkdale Industrial School.

immediately. The Poor Law Industrial School (pictured) was built nearby in 1842, designed to address the problem of 'juvenile pauperism', to teach destitute children useful trades, and as a result to alleviate pressure on the overcrowded workhouse on Brownlow Hill. It was palatial, both in its size and in the scale of its rather forbidding Tudor architecture, associated with educational establishments such as the Collegiate Institution. Designed for over 1,100 children, it contained a capacious schoolroom, play room and play shed (on the far side of the quadrangle) all over 70 feet in length and 30 feet in width. The boys chose their trades, the most popular being seamanship (there was a ship in the grounds for them to use as practice) while the girls were taught domestic work. It seems to have been well run at first but only a few years later was reported as overcrowded with most unsanitary conditions. The architect's drawing does not show the railway and Leeds Liverpool Canal just on the far side of the school, nor the docks further beyond on the banks of the Mersey. By the end of the century the landscape had been totally transformed. On the land side of the docks a huge infrastructure of railways had grown, the whole enveloped by housing as Liverpool expanded inexorably to the north. Kirkdale and its environs were then serviced by no fewer than fifty-three religious places of worship, thirty-three schools of different denominations and ten industrial schools or institutes.

Philharmonic Hall

The Liverpool Philharmonic Society was founded in 1840, one of the oldest in the world and second oldest in Britain. Their concert hall was opened in 1849. It accommodated an audience of 2,100 and an orchestra of 250, plus refreshment and retiring rooms. Boxes flanked each side of the hall surmounted by a gallery. Two more galleries faced the orchestra at the opposite end. Subscribers were invited both to buy shares and purchase seats in the boxes alongside the stalls. Concerts were important

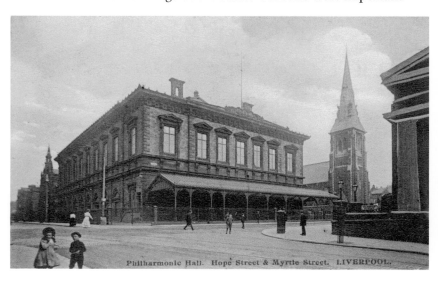

Philharmonic Hall.

social occasions and Jenny Lind sang two evenings for the benefit of the Society. The hall burned down in 1933 and was replaced by the new concert hall in 1939. The photograph, taken in 1912, is particularly interesting for showing the churches that used to surround the hall. From left to right, they are: (1) St George's Presbyterian Church, opened for worship in 1845. (2) Hope Street Unitarian Church opened in 1849, an early and unusual instance of a non-conformist chapel taking the form of a Gothic parish church. (3) The Chapel of the Blessed Virgin Mary, moved from Hotham Street in 1850 to make way for an extension to Lime Street station; Classical in style it had served as the chapel of the School for the Blind there. All three have been demolished to make way, respectively, for (1) an extension to the new Philharmonic Hall (2) office accommodation (3) an extension to the School for the Blind, all victims of demographic change.

William Brown Library and Museum

William Brown, born in Ireland in 1784, emigrated to the United States in 1800 but left there to live in Liverpool in 1809. He made a fortune in the linen trade and associated banking by capitalising on his connections across the Atlantic. With this he contributed £40 million in today's money to create the library (on the right) which bears his name and the museum (on the left). At the time it was by far the largest and grandest municipal museum in England. As can be seen, the sloping ground had to be built up to form a terrace which was later replaced by steps leading up to the entrance portico. A jumble of houses similar to those illustrated on the left were demolished to make way for the library. The drawing shows it soon after completion in 1860 when it

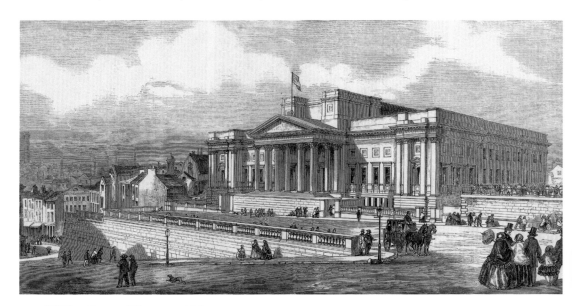

William Brown Library and Museum.

stood out in lonely majesty. This was before the Picton Reading Room and Walker Art Gallery were added to the right and, much later, the College of Science and Technology to the left, now joined with the William Brown Museum to form the Liverpool World Museum. When first built, the library formed a magnificent trio in Classical style with St George's Hall and the facade of Lime Street station. The basis of the library and museum's collections was those of the 13th Earl of Derby who was an enthusiastic collector of natural history specimens (including a menagerie). When he died, James Picton headed a committee to build a library and museum to house them. A Derby museum held the collection at first but William Brown stepped in with his offer to fund the building that bears his name. Joseph Mayer's Egyptian Museum was incorporated as well.

Playhouse Theatre

The theatre has its origins in the Star Concert Hall active in the mid-nineteenth century. In 1866 a new building, the Star Music Hall, was opened on the site in 1866. In 1896 this was rebuilt and renamed the Star Theatre of Varieties. The accommodation consisted of a gallery holding 800 people, a circle with boxes, and stalls on the ground floor. The seats were upholstered throughout, in old gold and red. Patrons could enjoy the comfort of five bars, lavatory accommodation 'for both sexes', and heating throughout provided by a hot water system with a cooling system that ensured an even temperature for both stalls and gallery. The latest safety features included a counterbalanced iron fireproof curtain and electricity throughout with a dual system

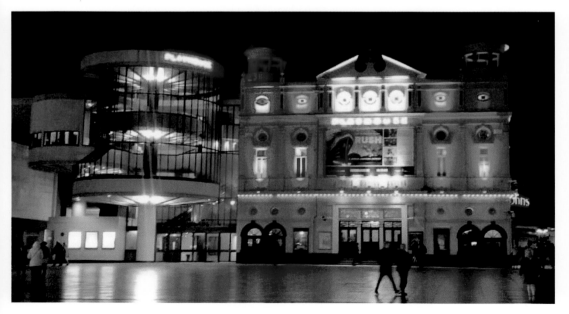

Playhouse Theatre.

in case of emergency. Since then, the interior configuration has altered but the new exterior, which was added in stucco at the same time, has survived. The modern colour lighting picks out the Classical detailing, especially the triangular pediment on top, the cupolas in the corners on either side and the windows below. The building was taken over by the Liverpool Repertory Theatre Company in 1911 and renamed the Liverpool Playhouse in 1917. The exciting modern glass three-cylindered extension was added in 1968.

Walker Art Gallery

The gallery was a noble expression of Victorian Liverpool's promotion of art, which had started in 1858 with the foundation of the Liverpool Society for Fine Arts. Steps, flanked by statues of Michelangelo and Raphael, lead up to the entrance through eight Greek columns in Corinthian mode, perfectly attuned to St George's Hall opposite. An imposing pediment leads the eye up to a statue of Liverpool. She has an honourable ancestry. There are many representations in the city of Minerva (Athene to the Greeks) who was the goddess of arts and crafts. She later morphed into Britannia holding a trident to associate her with Neptune, god of the sea. Here, she has been transformed into Liverpool as she is attended by a Liver bird, holding a propeller and sitting on a bale of cotton which accounted at one time for 30 per cent of Liverpool's imports

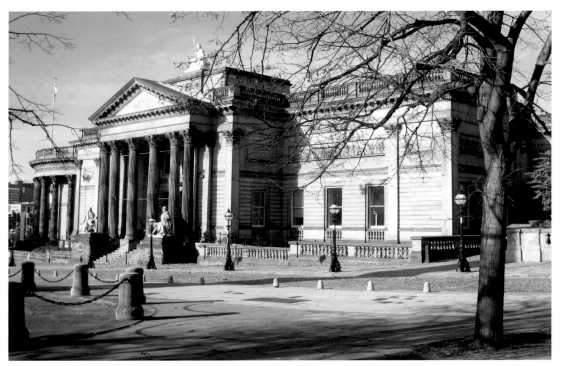

Walker Art Gallery.

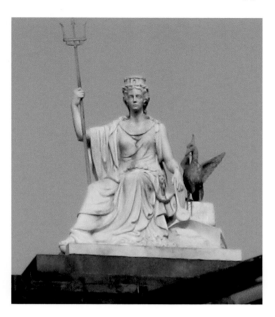

Walker Art Gallery statue of Liverpool.

and 42 per cent of its exports. Her support for art through commerce is proved by a painter's palette, compass and set square propped up by her feet. In fact, the gallery was named after the founding benefactor Sir Andrew Barclay Walker whose wealth came from a brewery business. He was born in Scotland but had moved to Liverpool and was a former mayor. The friezes on the wall picture four royal visits, starting with King John granting the town its charter in 1207 and culminating with the Duke of Edinburgh laying the foundation stone in 1874. In between can be recognised King William's embarkation from Hoylake in 1690 and Queen Victoria's visit in 1851 when she stayed with the Earl of Sefton at Croxteth Hall and enjoyed a sightseeing tour of the town (in torrential rain!). As can be seen, the circular Picton Library to the left forms a beautiful link round the slight angle of the street with the William Brown Library and Museum.

The collection originated in paintings acquired by William Roscoe. When he became bankrupt his friends bought them up and presented them to the Royal Institution in 1819. Proceeds from Autumn Exhibitions, held at first from 1871 in the William Brown Library and Museum, and later in the Walker Art Gallery, contributed to the purchase of works for the collection. A total of 900 paintings and sculptures were on show in the first exhibition which was oversubscribed the following year. It had been argued that it would encourage tourism and have great educational value.

Picton Readng Room

The Picton Reading Room is beautifully and cleverly designed. Its circular shape and style echo the rounded shape and Corinthian columns of the north apsidal end of St George's Hall opposite. It is appropriately flying his flag. Opened in 1879, it was

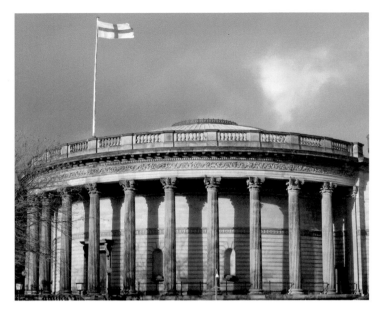

Picton Reading Room.

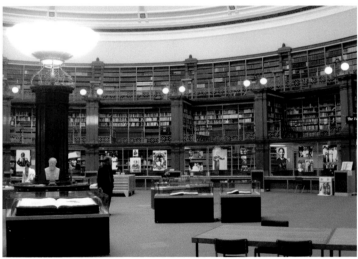

Picton Reading Room
showing Audubon's *Birds of
America*.

built as an extension to the William Brown Library and filled the gap between it and
the Walker Art Gallery opened two years earlier. Being circular, its axis neatly turns
the curve of William Brown Street (previously Shaw's Brow) at this point. The design
was modelled, about three-quarter size, on the Reading Room of the British Museum
built in the 1850s. It was almost certainly the first public library in the country to be
lit by electricity. Underneath was a theatre, later used as the International Library and
now converted to educational use. As can be seen in the photograph, a glazed dish
housing three carbon-arc lamps was mounted on an octagonal wooden support in the
centre of the room. The glass case in front of it at the time displayed one of the library's
greatest treasures. Joseph Shipley, one of William Brown's business associates, had

bailed him out with a huge loan in the international banking crisis of 1837. Invited to the opening, but unable to attend, Joseph generously extended his largesse and made a large donation instead. This was used to buy, appropriately, a copy of Audubon's *Birds of North America*, worth approaching £10 million today. It has since been moved to the Oak Room off the Hornby Library which was built adjacent to the Picton Reading Room in 1906. The library was named after Sir James Picton, Councillor for the Lime Street Ward, Chairman of the William Brown Library and Museum Committee and prolific historian and architect. His designs were inspired by the facades of Venetian palaces and he was knighted for his services to the city.

Shipperies

The International Exhibition staged in Liverpool in 1886 was the first one of its kind in a provincial British town. Its full title was the International Exhibition of Navigation, Commerce and Industry but this was shortened to the 'Shipperies' because of the huge emphasis placed on shipping: many model boats and maritime inventions were on display in the main hall. The aim was to showcase Liverpool as second city of the Empire and promote the city as a gateway for shipping in and out of the port and the country. A Colonial and Export Exhibition in Amsterdam had been held the previous year and buildings from Amsterdam were recycled for use in Liverpool. A Grand Triumphal Arch and life-size copy of the Eddystone Lighthouse were specially constructed. The exhibition was opened by Queen Victoria who then viewed the displays and

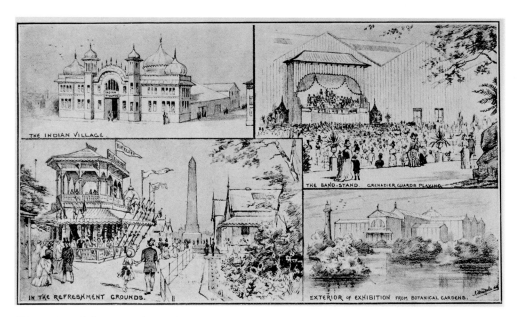

Shipperies exhibition with (clockwise) Indian village, grandstand, exterior view and refreshment grounds.

entertainments on offer. Potential participants had been encouraged by the offer of gold, silver and bronze medals, and diplomas of honourable mention were awarded to exhibitors on the recommendation of juries. One of the winners was the Laplanders Village (accompanied by three reindeer) in competition with a Japanese Village and an Indian Village (illustration, top left) with fifty 'natives' including dancers, conjurors and a snake charmer. Also shown are the Grenadier Guards playing in the bandstand, the refreshment grounds and a view with lighthouse from the adjacent Botanical Gardens. Popular attractions ranged from Grace Darling's Boat to a Gipsy encampment, a West African Ashanti palace, Canadian tobogganing track and Chinese pagoda. Over three million visitors enjoyed the daily highlight of a procession of animals with performing elephants, camels, zebras and llamas. However, although there was a move to extend it for another year, it had made a loss and was not repeated then or ever.

Educational Institutes for Young People

The Gordon Working Lads Institute was the first educational institution for young people to be established in Liverpool in 1886. It was built by William Cliff, a merchant and shipowner in Kirkdale, to the north of the city, in memory of his son, Gordon. He had also largely funded the Liverpool Home for Aged Mariners in Wallasey in 1882. Three years later in the south, the Florence Institute (known as the Florrie) was founded by Bernard Hall who named it in memory of his daughter, Florence, who died in Paris at the untimely age of just twenty-two. As a plaque there proclaims, he was a 'West India Merchant and once Mayor of this City' and he wanted to create 'an acceptable place of recreation and instruction for the poor and working boys of this district of the city'. In both these cases private sorrow inspired public charity, although the money came from inherited wealth derived from the slave trade. The Bankhall Girls Institute, a companion to the Gordon, was also funded in 1889 by a merchant and shipowner, Thomas Worthington Cookson. It was sited only a hundred yards away, similar in form but on a smaller scale. To be made effective, the act of philanthropy had to attract young people away from the allurements of the pleasures of pubs and other distractions. So, as can be seen, they were built on a grand scale with architectural and decorative enhancements. The Gordon Institute has lost its cupola and finials at roof level but the Florrie has regained its lost onion dome and roof in a recent restoration. They were also positioned to catch the eye of potential students. The Kirkdale Institutes fronted onto Stanley Road, the main thoroughfare into the city from the north, while the Florrie was on a corner site, designed to be seen from four directions, and belittling a pub on the opposite corner. A spacious top-lit gym, great hall on the first floor that could accommodate a thousand people and well-appointed social room ensured that the Florrie acted as a local community centre in addition to serving its primary function of educating and training more widely. The Gordon Institute could house 600 in its hall and like the others host entertainments in the evening with bright lights illuminating the neighbourhood. All the buildings have withstood the test of time and are still performing their role, in a modern way, of affording the young opportunities for education and recreation.

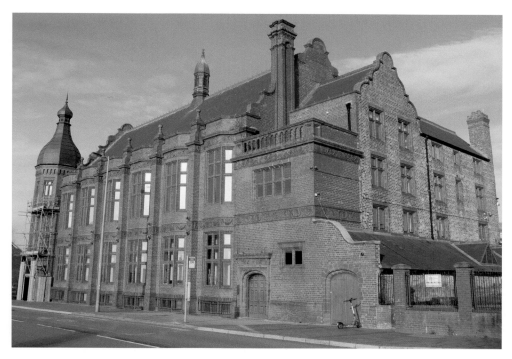

Florence Institute.

Gordon Working Lads Institute.

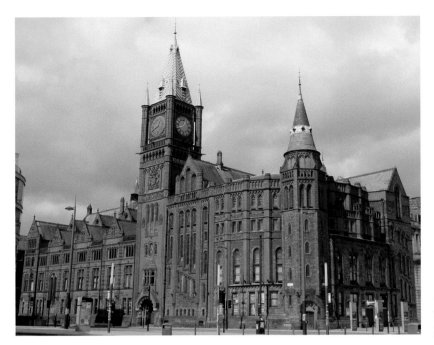

Victoria Tower,
University of
Liverpool.

University of Liverpool

This is the archetypical university building of 'red brick', a term coined in 1943 by a Liverpudlian professor. It was one of the new breed of university institutions established in the latter half of the nineteenth century. In Liverpool it originated in the enthusiasm of the town's medical school and merchants. William Rathbone, freed of parliamentary duties by his defeat in the elections of 1880, spearheaded a fundraising campaign. 'University College Liverpool' started in a disused lunatic asylum next to the workhouse (!) and joined the federal 'Victoria University' of Owens College, Manchester and Yorkshire College, Leeds. A steady growth of mainly scientific and medical endowments and buildings over the following twenty years was epitomised by the striking red-brick Victoria building. This was the main administrative and teaching block completed in 1892, a masterpiece of Alfred Waterhouse. The main entrance rises to the clock tower; to the left, gables mark the library; to the right, the staircase merges into the tower and the curve of the lecture theatre is delineated behind the coned corner tower. Inside, the hall displays Gothic bravado as lavishly as the exterior with eye-catching glazed tiling, impressive staircase and extravagantly hooded fireplace. 'Liverpool University' received its royal charter in 1903.

Everton Library

Prominently situated at the apex of a triangular piece of left-over land, and brilliantly designed to make full use of the opportunity, the Everton Library is an iconic work

of Thomas Shelmerdine. As the picture shows, it is now in a poor state of repair and garlanded with 'We're losing our heritage' on a banner (how did it get there?!). Originally the site of a beacon for the ships, the tall ornamental octagonal tower aimed to guide local residents into the ways of learning. Shelmerdine, the youngest City Surveyor, whose motto was 'modernise everything', departed from the old Liverpool tradition of Classical or Gothic architecture. Here he adopted an Art Nouveau style. Low relief stone panels display highly decorative flourishes especially over the main entrance (illustrated) and around the foundation stone. Twenty-five thousand volumes were available for perusal in a general reading room which rose through two storeys and was lit by roof lights. In addition, the ladies and boys had separate reading rooms, and a technical school occupied two levels. Fiction was preferred by working-class readers but frowned on by management who favoured educational instruction. Opened in 1896, closed since 1999, the building is being made secure for future development.

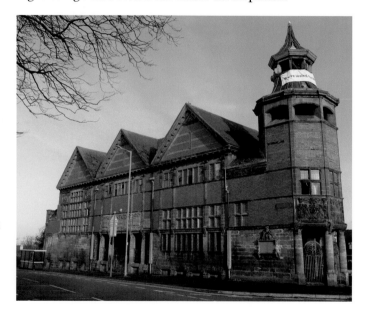

Right: Everton Library. The foundation stone is on the right below the tower.

Below: Everton Library decoration over main entrance.

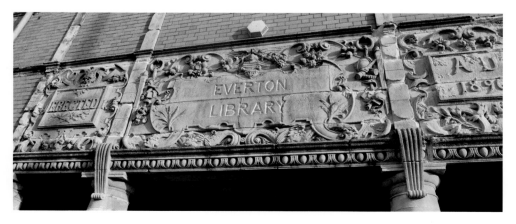

6

HEALTH

St John's Market

The plan of St John's Market is shown in two halves to be imagined side by side. Although opened in the Georgian era in 1822, the plan makes an instructive comparison with, for example, the high-class fashionable shopping of Bold Street in Victorian times. The perimeter of the great hall is surrounded by fifty-eight shops. Starting from the main Great Charlotte Street entrance and turning left you are faced

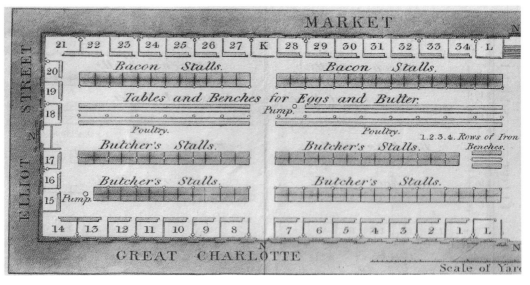

St John's Market southern half. The main entrance is bottom right.

with two ranks of 102 butcher's stalls in total with four rows of iron benches. They were served by a pump, one of four strategically placed in each quarter. Two rows of tables and benches are then allotted to eggs, butter and poultry followed by fifty-six stalls for bacon. Crossing to the other side there are a further set of unspecified benches with stalls for fruit, fish, greens, eggs and potatoes. A contemporary print shows stalls piled high with produce and well-dressed families promenading and perusing the wares, which they could until eight or nine o'clock in the evening. However, the market eventually decayed through neglect and was demolished in 1965.

Royal Liverpool Medical Institution

Opened in 1837, the Medical Institution was built to house a medical library founded on the same site in 1779. Besides the library with its priceless collection of books, there are committee rooms, a dental museum and double-height lecture theatre. In the entrance hall there is a memorial to Dr Duncan, the first Medical Officer of Health in Britain, telling us that 'Dr Duncan was appointed under the Sanitary Act of 1846, which was obtained chiefly through his exertions, and by his judicious measures under the blessing of God, he succeeded in reducing the rate of mortality in Liverpool by nearly one third.' He had published a book on the 'Physical Causes of the High Rate of Mortality in Liverpool' in 1843 proving the link between poor living conditions and the spread of disease, and arguing for government intervention to support much-needed change. The council responded immediately with a minute which recognised that 'the lower classes of its population are crowded together in Confined Courts and Cellars without due regard to ventilation and drainage and without adequate arrangements for the removal of filth'. Another Liverpool medical first was the School of Tropical

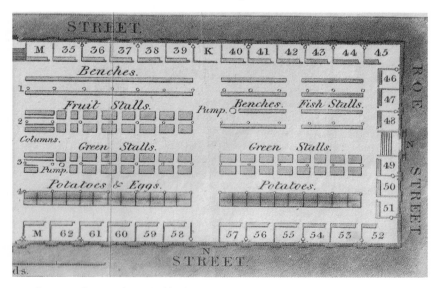

St John's Market northern half. The main entrance is bottom left.

Medical Institution library with board of past presidents.

Medicine, founded in 1898. It was the first institution in the world dedicated to research and teaching in that field.

Courts and Back-to-Back Houses

In 1847 average life in Liverpool was twenty-five years nine months compared with a rural Lancashire town of forty-one years eight months. Dr Duncan, Liverpool's Public Health Medical Officer, stated in the 1840s that Liverpool was the unhealthiest town in England. Much of the reason for this was overcrowding in poor dwellings. He recorded

Back-to-back houses in Duke Street.

the desperate plight of the thousands who lived in cellars, most of them only 10–12 feet square and housing four or five people. A huge number lived in enclosed courts where there would be a single contaminated water supply breeding typhoid fever and cholera. Even in the back-to-back houses water was sold from carts and there was inadequate sewage. All of this has disappeared except one terrace (pictured) built around 1840. It has been converted so that each back-to-back has been joined to its companion with a front and back garden. The originals would have been much more cramped and unhealthier.

Workhouse

In 1842 expansion of the area round the Georgian workhouse was designed to house 3,000 residents (peaking at 5,000). In the 1850s and 1860s many of these were vagrants seeking work. They were given a basic meal and shelter, and then set to work for which they were paid before being sent on their way. Until the 1860s the sick were being nursed by infirm female paupers. Then William Rathbone offered to pay a trained nurse to reform the evils of this practice, which was achieved by the appointment of Agnes Jones, a friend of Florence Nightingale. People were reluctant to enter the workhouse because of the loss of their independence, abysmal conditions, immorality and perceived disgrace. Until its demolition in 1931, the workhouse filled the whole of the site now occupied by the Metropolitan Cathedral, as shown in the aerial photo of around 1930 when the site was closed. Top left is the Victoria Tower of the University on Brownlow Hill from which Mount Pleasant descends diagonally on a gentle curve bottom right. Many of

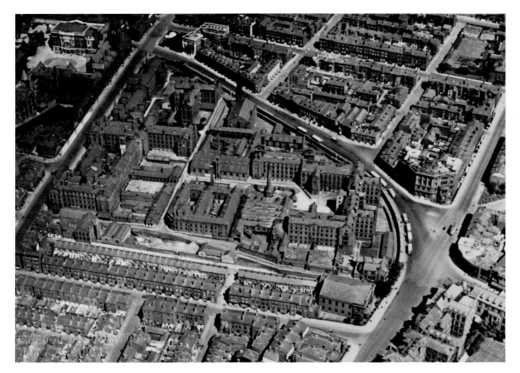

Workhouse.

the Victorian facilities of that time can be traced. There are no people visible on site and the road alongside was being used as a bus terminus. Running from bottom to top, the left-hand line of buildings used to contain the administrative buildings but the governor's house and garden of the time have disappeared. This and the next line accommodated men and boys (the women were at the other end). Epileptics and 'lunatics' (significantly alongside each other) were incorporated into this section together with the fever hospital with its separate airing grounds for men and women and room for a matron. Next came the baths and dining hall leading up to the church with schoolrooms below and playgrounds alongside. Laundry and drying rooms (note the chimney) were next in line and finally wards for epileptics, female classification, lying in, children in arms and aged women. Here there used to be three substantial 'airing grounds' (since built upon) for the women. This was in significant contrast to the men at the other end who had separate 'yards' for infants, boys, the able-bodied, epileptics, the infirm and aged.

Sailors' Home

As the docks expanded, the efficiency and reputation of the port was greatly enhanced by the Sailors' Home. It provided safe accommodation for an average of 200 men each night at a moderate charge with medical attendance. A savings bank encouraged them to preserve their earnings and a registry of character was kept. Inside a central

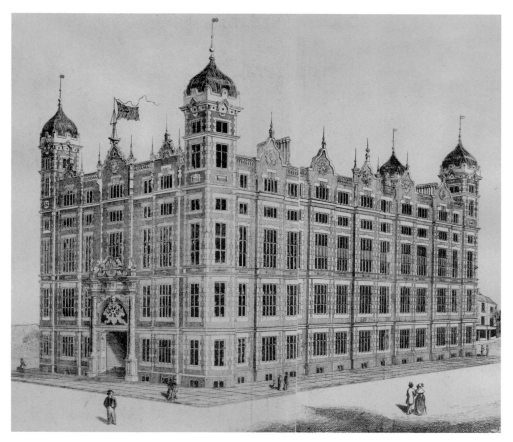

Sailors' Home.

space, six floors of galleries guarded by decorative ironwork led off to dormitories consisting of forty-four cabins at each level. A reading room and library improved sailors' education and the home aimed to promote their moral, intellectual and professional development along with religious instruction. The home's community provided opportunities for the interchange of useful ideas and links for advancement. Whether to impress the sailors or town dwellers, or both, the building was designed in the neo-Elizabethan Tudor style of the great houses of Wollaton and Hardwick Hall, and was extravagantly embellished particularly at roof level and around the entrance. Elsewhere it was rather austere on the outside, only alleviated on the inside by the decorative iron of the guard rails. Opened in 1850, the home was closed for two years after a disastrous fire in 1860. However, the original Liverpool-based partnership of architect John Cunningham and ironwork founder Henry Pooley were undeterred and restored the building. Beautifully crafted gates inside the entrance served the dual purpose of protecting the Savings Bank and ensuring that the sailors kept to the strict 10 p.m. curfew. A golden Liver bird surmounted by a crown rests its wings to greet the weary sailors with its trademark seaweed in its beak. It is surrounded by an intricate

Sailors' Home gates.

nautical design that abounds in dolphins and incorporates oars, rigging, hooks, ship wheels, horns and shells. Amidst the rope tracery of the lower half, mermaids, picked out in gold, sport twin tails and garlands of shells, and are transfixed by the tridents of Neptune, god of the sea. The gates reflected the ironwork railings which guarded the galleries running round the inside of the home. Following war damage, they were removed in 1951 to the museum of the successors of the firm who had manufactured them. Bought back and restored by the council in 2011, they now stand near to the site of the original Sailors' Home.

School for the Blind

Queen Victoria, Prince Albert and their four children visited this new School for the Blind a few weeks before the opening in 1851.The old Georgian buildings were being demolished to make way for extensions to Lime Street station (from where the Queen departed for Manchester). The Committee had negotiated a good deal with the railway company for a relocation allowance for the chapel and school, and also replacement costs for the building. More spacious and up to date, it was in a healthier part of town: the Queen braved a cholera epidemic that was raging. The entrance range to the front led to a domed rotunda. From this, wings radiated as in a workhouse which facilitated segregation of the sexes. A music room was equipped with an organ and orchestra space for practice to maintain the strong choral tradition for the chapel next door. There were separate music rooms, exercising ground and work room for the females. The school provided its pupils with practical training in trades in order to equip them to be independent and self-supporting. There were opportunities for rope and brush making, knitting, basket work, piano tuning and reading braille. A shop

School for the Blind.

in front sold items made by the pupils. Single-storey wings along the front were later raised to two storeys. The school has now moved to Wavertree. As photographed in 2006 with reflections of a setting sun, the building was occupied by the Merseyside Trade Union, Community & Unemployed Resource Centre.

Walton Prison

The impressive but forbidding entrance of the prison with its massive towers in military style is reinforced by the interior blocks visible behind. Opened in 1855, it was specifically designed for separate male/female confinement. Unfortunately, although built to accommodate 1,000 inmates, it was frequently overcrowded, particularly in the female quarters, so that the aim could not be fully realised. There was a shift of attitude generally away from trying to reform criminals towards deterring them with a harsher system of punishment. Prisoners endured the treadmill for six or seven hours a day, compulsory from 1865 for adult males sentenced to hard labour. It was argued that as a result repeat offending and the whole prison population would be reduced. However, numbers increased and by the early 1890s 20,000 prisoners a year were being committed, mostly on short-term sentences. Anxiety and distress

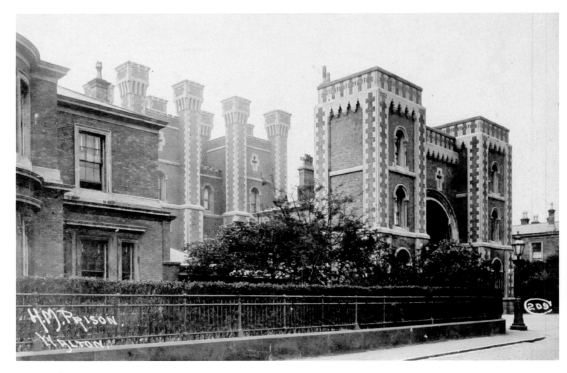

Walton Prison.

were accompanied by mental disorders and attempted suicides, which were often treated as shamming. Following Irish immigration during the potato famine and the accompanying plight of women, a high proportion were Roman Catholic, of Irish descent and female. The overcrowding (the prison was the only one in the world where females outnumbered males) led to behavioural patterns of prostitution and drunk and disorderliness.

Everton Water Tower

At the start of the nineteenth century water carts were used for what was seen as a necessity for health. With the increase in population and industry, extra provision was needed, if only to hose down the streets to remove animal manure and other decaying material which was believed to harbour disease. The problem was partially alleviated by the 6-acre Kensington reservoir, eventually all vaulted over to provide a green open space. By 1845 however, the quantity of water required rose from ten gallons per head per day to twenty. Two rival schemes were mooted to draw water: from the Lancashire hills at Rivington or from Wales at Bala. A dispute went to law and the huge costs were increased still further by parliamentary fees. Money was also paid out to the water companies that had to be bought up by the corporation in compensation for their

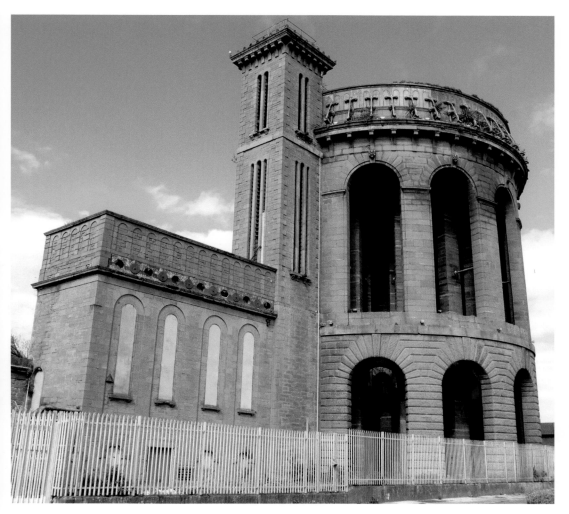

Everton Water Tower.

losses. The Rivington promoters won the contest. The pipeline, 44 inches in diameter and 17 miles long to storage reservoirs at Prescot (a record at the time), finally delivered the supply to various reservoirs in the town. The Everton water tower of 1857 was one of the most impressive Victorian monuments in Liverpool, 85 feet high to the tank. Apart from its size, it exhibited style with a rusticated Romanesque base. There was also a hint of Classical columns on the smooth stone of the second storey, the tank and the curved supporting brackets of iron at the top. Next to it is a pump house with patterned tank. The tower between is enhanced right to the very top with antefixae (decorations that would grace Classical temples) silhouetted against the sky. There is another separate pump house to the south. By 1874 it was clear that further water supplies were needed, to be fed by gravity. Lake Vyrnwy was chosen, provoking the accusation that Wales was being 'robbed' of its water.

Liverpool Ecclesiastical and Social, 1858

Opposite above: 'Liverpool Ecclesiastical and Social by Revd A. Hume 1858' (orientated to the east).

The colours indicate the growth of the town by stages from 1600 where the H of the original five streets stand out in pink (centre bottom). The limits of growth are then shown in green (1725), yellow (1765), blue (1785), orange (1821) and pink (1841).

Social deprivation is recorded by streets being marked as 'Pauper', 'Semi-Pauper' or 'Streets of Crime & Immorality'. There are different signs for Churches, Roman Catholic Chapels and Dissenting Chapels with an indication if they are temporary. Schools are further differentiated if they are church schools or under inspection, and churches if they have an incumbent, curate or scripture reader.

The keys to the two circles on the map compare two areas of the town as follows:

On the left: 'Church Accommodation for the Poor: The North Western Circle 500 Yards radius, contains population of 35,000 and twelve Public Churches and Chapels 1 for 3000 nearly'.

On the right: 'Church Accommodation for the Rich: The South Eastern Circle 500 Yards radius, contains population of 10,000. There are within it Twenty Seven Public Churches and Chapels and Three Private ones 1 for 350 nearly'.

The two areas roughly equate to the Vauxhall/Exchange wards and the Georgian Quarter.

Canon Hume gained his information with the help of Poor Law Relieving Officers. He worked out that the wants of the poor were better supplied in one district by 25,000 to 1 than in another. 'It is' he said 'a crying evil that two communities whose members dwell side by side ... should in many respects be practically as wide apart as if they resided in two separate quarters of the globe.'

Opposite below: a detail attached to the map above, 'Liverpool showing Pauperism, Cholera and Violent Deaths'.

The position of the map (orientated to the east) can be fixed by looking for the black on yellow of the Custom House on the site of the Old Dock (bottom centre right, now Liverpool One) and the Cemetery Mount (centre right, now the Anglican Cathedral). The limit of expansion of the town on the left is defined by the only inland Stanley Dock and the two connected docks linking it with the river.

Referring to the areas in light and dark green, the key states: 'The dots indicate the parts of the town visited specially by cholera in 1849. The darkest area is peculiarly the region of Violent Deaths.' These are labelled (hardly visible) Northern Pauper Area (to the left) and S Pauper Area (to the right).

In 1849, 6,394 deaths from cholera were recorded. Two years before, during a three-month period from January to April in 1847 an astonishing 127,850 Irish people had arrived in the port following the famine migration of 1846/47. Although many of these may have passed on to other areas, the resultant overcrowding and the strain it put on sewage disposal must have contributed to many of these deaths.

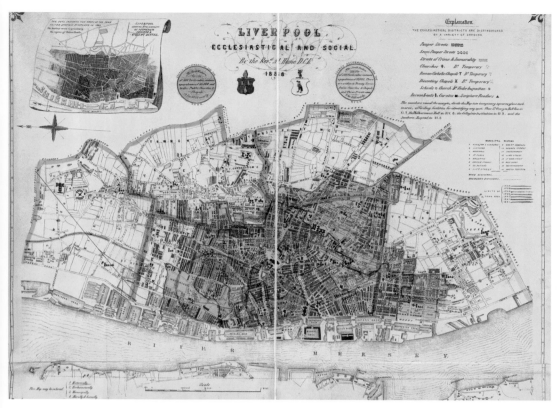

Liverpool Ecclesiastical and Social, 1858.

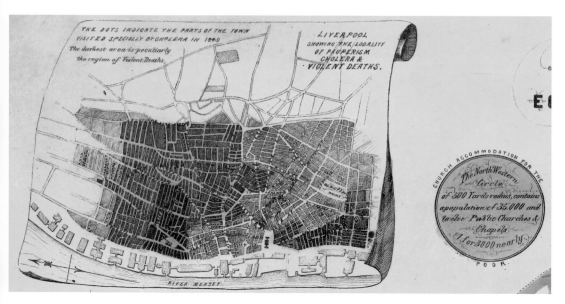

Liverpool showing Pauperism, Cholera and Violent Deaths.

The Eagle.

The Eagle

In the 1840s there were reckoned to be 900 beer houses and 1,500 pubs in Liverpool. They were unevenly distributed. The Eagle stands on the corner of Blackstock Street and Vauxhall Road. In the 1850s it had only one competitor in the street but along Vauxhall Road there were nineteen pubs within a distance of 800 yards. The pub was well managed as it only figured once and then only tangentially in a newspaper report. This was in spite of the nature of the area. The street was categorised as being 'semi pauper' but neighbouring streets were distinguished by 'crime and immorality' and the area was severely affected by the cholera epidemic of 1849, 'peculiarly the region of Violent Deaths'. However, the poverty, suffering and despair was alleviated by three nearby Anglican churches with a number of scripture readers. There were also many relief organisations nearby, including St Saviour's Catholic Church, a home laundry, and a refuge and night shelter for fifty 'fallen women' run by Father Nugent, the philanthropic Catholic priest. How is it that the Eagle is the only Vauxhall Street pub to survive to this day?

Blackstock Street

Blackstock Street in the Vauxhall area of Liverpool was an interesting mix of residences and industry in the latter part of the nineteenth century. Irving, Son & Jones, flour and rice millers, was one of the four main factories. Another, the Liverpool Saccharine Company, specialised in producing sugars for the brewing industry. Two others were strongly linked: E & W Pearson crushed seed to extract oil and the Liverpool Vesta Cake Company produced cattle cake, a by-product of seed crushing. Three other factories of lesser importance completed the variety. There were huge differences in

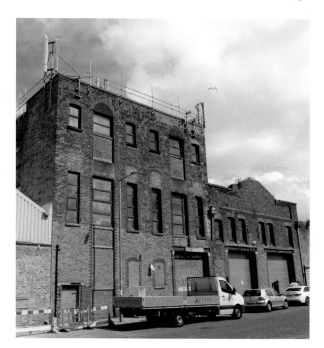

Blackstock Street Victorian
industrial premises restored.

living standards and income amongst the residents with a shifting population. Few
families stayed more than ten years. In 1901 the most affluent, although headed by a
general labourer, included two working children, one a cotton porter. The other was a
'telephone wireman', the right job to have in a burgeoning new technology. Although
all the factories had a line, no private house did. Contrasting with this family, a carter
with his wife and four young children was living in one of eight households in a court
that contained twenty-eight people in all. Nearly 50 per cent of the wage earners were
general labourers (the docks were close). Pay was low and erratic, so pawnbrokers and
moneylenders would help out and women might resort to prostitution.

Silvester Street

The photo of a Silvester Street court demonstrates the remarkable changes that the
expansion of Liverpool wrought in Victorian times. In 1825 John Foster Junior, the
leading architect of the day, designed a church, 'St Martin's in the Fields', in Oxford
Street North (now Silvester Street). It was a commissioners' church with a grant to
provide extra accommodation for towns affected by the Industrial Revolution.
St Martin's received a grant greater than any other in the country to provide (for a
congregation of 2,000) 1,500 free seats that did not require the payment of pew rents.
Although it really was in the fields, it was, as anticipated, quickly overwhelmed by new
housing, including the court as illustrated.

The strong community feeling occasioned by the confined living is beautifully caught by
the camera but belied by the cramped quarters behind the scene. There might be a single

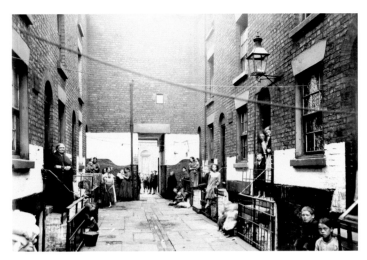

Silvester Street court.

contaminated source of water breeding typhoid fever and cholera. Better-dressed children peep in through the doorway with what looks like a church, possibly Presbyterian, in the background. People who lived in cellars were very much worse off. The roof was so low that even a person of moderate height could not stand upright, and the floor was often of bare earth. Besides being dark and ill ventilated the inhabitants were frequently without clothes, fire or food – and the hope of getting any. Children were born into such deprivation and, if they survived, might be taken from school (if they attended at all) to earn money through begging. The aged or infirm might shiver out the last hours of their lives in utter absolute destitution, if they had not been incarcerated in the workhouse.

Gymnasium

The Gymnasium was claimed to be the finest and largest in Europe, if not the world, when it was opened in 1865. Equipped with climbing wall, ropes, ladders and wall pulleys, it even featured a live horse, and offered training not only in gymnastics but also fencing, rowing, swimming and cycling. The huge hall accommodated all sports, but fencing and boxing had their own facilities. The venture was publicised to promote 'healthful exercise for girls' and women could watch special events such as bicycle tournaments from attractive galleries. The participants rode penny farthing machines called velocipedes, performed tricks while holding onto the handlebars with one hand, negotiated a steeplechase with obstacles and tilted in imitation of medieval jousting. Funds were raised for the neighbouring Children's Infirmary. The events were run by the flamboyant self-styled 'gymnasiarch' John Hussey who helped to organise the first Olympic festivals, precursors of the modern Olympic Games. He formed a Liverpool Velocipede Club which held popular cycle races. John had founded the gymnasium with Charles Melly, cotton merchant, councillor, philanthropist and father of the celebrated local pioneer aviator Henry Melly. The view (from the *Illustrated London News*) shows the main hall at the back, lit by a

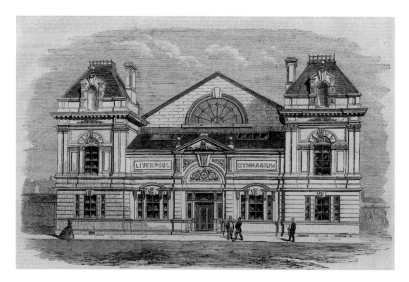

Gymnasium.

large circular window. An imposing and decorative facade has been added to it with a mix of Classical, Gothic and French mansard roof similar to the new Exchange Building completed in the same year. It was used as a youth centre until 1960 and subsequent demolition.

Seamen's Orphanage

This building, more than any other, demonstrates the importance of trade to Liverpool and its attendant risks. Over 300 destitute children could be trained here, boys until the age of fourteen proceeding into trade and girls until fifteen and then into household service. There was no bar on nationality, but Liverpool seamen were given preference. Alfred Waterhouse, no less, was commissioned for an economical design in brick, with

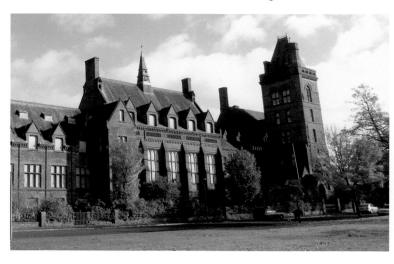

Seamen's Orphanage.

some stone dressings, although the tower was unnecessarily showy. The boys' quarters (on the left) overlooked the park, the girls were round the corner of the tower to the right. The dining room between was on a grand scale with three-light windows, brick patterning above, an ornamental fleche on the pitched roof and a minstrels' gallery inside. The chapel (behind the boys' range, but now demolished) attracted visitors on Sundays who would be impressed by the discipline and religious upbringing of the children. Following its opening in 1874, a sanatorium, chaplain's residence and swimming pool had been added by 1900. After closing in 1951, it looked after physical and mental health until 1997. At the time of writing, awaiting redevelopment, it hosts ghost hunts.

Steble Street Baths

Hot water, a sink, tub and dolly for twirling the clothes like a washing machine were a gift for the poor at Steble Street Baths. Here, eighty cubicles on two levels can be seen with adjacent drying, ironing and laundry areas. First-class, second-class and juvenile plunge baths, and individual men's baths, were also offered on site. Similar establishments provided private bathrooms and privies which were conveniently situated next to areas with ash, helping to produce soap, particularly for infected clothes. Reading rooms enhanced the usefulness and pleasure of social activity. The Steble Street Baths, opened in 1874, were part of Liverpool's innovative and distinguished progression in improving health in the town. Kitty Wilkinson had led the way in the aftermath of the cholera epidemic of 1832 by providing washing facilities in her own home for others. This led to the opening in 1842 of the first public washhouse and private baths in the country, in Frederick Street. Owing to her unstinting efforts to help the destitute in spite of her own difficulties, Kitty was presented by Queen Victoria with a silver tea service in 1846 and

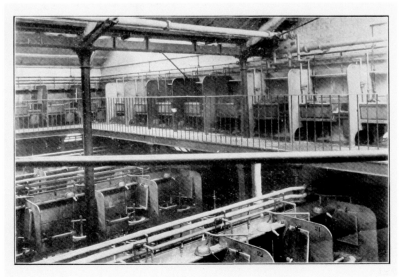

STEBLE STREET PUBLIC WASH-HOUSE.

Steble Baths.

then appointed matron of the baths with her husband as superintendent. That was the year that Irish immigration reached nearly 300,000 in flight from the potato famine. The death rate was the highest anywhere in Britain and Dr W. H. Duncan became Public Health Officer, the first such appointment in the world. By the end of the century, thirteen baths and washhouses had been opened. The Steble Street Baths are now part of the Park Road Sports Centre in the south of Liverpool.

Toxteth Terraces

In the 1890s Liverpool Corporation built 'destructors' to incinerate waste. The heat produced was used to generate electricity and the clinker made concrete for prefabricated housing. An intrepid photographer took this aerial image from the chimney of the Lavrock Bank destructor on Beaufort Street in Toxteth in 1903. Originally a royal hunting forest, the Toxteth Park was turned over to agriculture from the start of the sixteenth century, then to housing and industry. Amidst the sea of Victorian terraces and back-to-back houses two churches stand out. Halfway along Beaufort Street, which runs from the bottom left of the photo along the line of a reservoir, St Gabriel's Church can be seen (still standing). It was built on the site of an earlier temporary iron church which had proved inadequate for the growing population after only five years in situ. To the right can be seen the steeple of the Church of St John the Baptist, consecrated in 1832. At the time it was described as lying 'in the midst of fields and meadows, and was attended by a congregation of advanced social status'. The scene of 1903 shows how it had changed completely in both respects in the intervening years. By 1842 labourers were already hard at work building houses and spoiling the view of the smoke-laden town which would soon engulf all the villages on its perimeter.

Toxteth terrace houses from the air.

7
RECREATION

Princes Park

Princes Park was the first initiative to provide open space in the town through a semi-public park. Joseph Paxton, the noted landscaper and architect, was engaged to design the park with a lake as its central feature. People with high social aspirations were also to be attracted by superior residential opportunities. Princes Park Mansions, winner of an open competition, was the first to be built in 1843. St Paul's Church was an integral part of Princes Park. It was consecrated by the Archbishop of Canterbury in 1848 and paid for by George Horsfall, one of the family who founded a number of churches in Liverpool including St Margaret of Antioch (see page 89) and nearby St Agnes and St Pancras. In the distance can be seen one of the grand terraces that surrounded the park, and the people dressed in their finery leaving the church will doubtless be living in one of them. The new suburb was built around the park and was approached by the grand

Princes Park
Mansions.

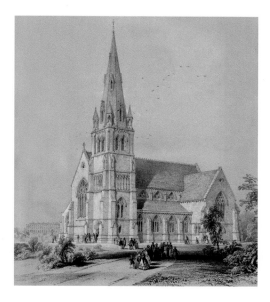

St Paul's, Princes Park.

boulevard formed by the twin carriageways of Princes Road and Princes Avenue. Along it stood many beautiful places of worship, starting with the Greek Orthodox Church on the corner of Upper Parliament Street and quickly followed by Anglo-Catholic St Margaret of Antioch, the Synagogue, Welsh Presbyterian, Presbyterian, Methodist, Baptist and Anglican All Saints'. St Paul's was demolished in 1974.

Botanic Gardens

When Queen Victoria came to visit Liverpool in 1851, she stayed at the nearby Knowsley home of Lord Derby and passed the Botanic Gardens on her way into the town in torrential rain. The entrance to the gardens had been specially decorated in

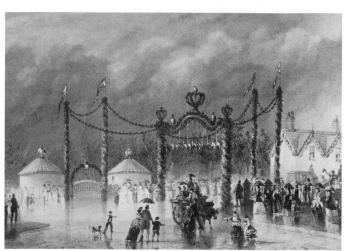

Botanic Gardens decorated
for Queen Victoria.

honour of the occasion. A magnificent triumphal arch had been constructed and on the top were placed live eagles, parrots and other birds which remained there all day. It is said that the severity of the weather caused the death of most of them. Here, the artist has imagined the people flooding, almost literally, into the gardens in the evening, still in the rain. Protected by umbrellas, they are dressed in their best and fashionably for the royal occasion. The two rustic lodges were used as pay places. Subsequently the tone of the gardens declined 'until they became notorious for the low dissolute characters which resorted thither'. They were closed in 1865.

Sefton Park

Sefton Park Palm House was the culmination, in 1896, of the development of the grandest of Liverpool parks. Long before, in 1850, it had been proposed to create a 'ribbon of parks' around the town to give easy access to open space for all its inhabitants. Newsham Park was opened in 1868 and Stanley Park soon after in 1870. In the meantime, a prize of 300 guineas (£40,000 today) had been offered in a design competition for Sefton Park. Implementation took many years before and after the official royal opening in 1872. Its 269 acres were landscaped with sweeping curves to enhance the natural beauty and contrasting sequestered delights, such as the dell. It was a hugely upmarket plan with 160 acres of associated building plots for sale. The boating lake offered the enjoyment of swans, ducks, rowing boats and a pirate ship. Visitors were also attracted by the cricket club, an aviary and concerts at the bandstand. The Palm House was decorated with statuary inside and out celebrating Liverpool's maritime heritage and major contributors to botanic science and gardening. This statue,

Above left: Sefton Park Palm House.

Above right: Statue of William Rathbone in Sefton Park.

a picture of relaxed confidence and vision, honours William Rathbone, a name passed down through six generations. It was funded by public subscription and sited in Sefton Park to be in the public gaze near the family home of Greenbank. The family more than any other epitomised the promotion of the well-being of Liverpool in the Victorian (and before that, the Georgian) era through educational and cultural enterprises based on their Unitarian beliefs. This William, the Fifth, born in 1787, became Mayor of Liverpool at the very start of Victoria's reign in 1837. A staunch Liberal in a town that had strong Conservative leanings, he was instrumental in carrying out the aims of the Municipal Reform Act of 1835. He fought for the freedom of West Indian slaves and, although a Unitarian in religious observance, for Catholic emancipation. He oversaw the distribution of Irish famine relief contributed by the New England states. He was not only a founder of the Liverpool Mechanics Institute but opened the Liverpool Corporation Schools to all sects so that children of any denomination could benefit from them, despite heated opposition. His son, William the Sixth, is distinguished with a statue in the newly created St John's Gardens under the shadow of St George's Hall. Blest with many of the attributes of his father, as recorded on a plaque at the base of his statue, he was elected a Member of Parliament for a total of twenty-five years, first for Liverpool and then for Caernarvonshire. He was a founder of the University Colleges of both Liverpool and North Wales. He established a training scheme for nurses following the principles of his friend Florence Nightingale, and appointed one of them superintendent of the workhouse at his own expense. His daughter Eleanor was a notable politician and reformer.

Steble Fountain

In 1885 a small triangular rubble-strewn patch of ground was left between St George's Hall and the Walker Art Gallery which begged for improvement. Lieutenant Colonel Richard Fell Steble, former mayor, gallantly stepped forward with a gift worth around £100,00 today to defray the cost of a fountain. The design was based on a similar one in Boston, Massachusetts, USA, with appropriately nautical decoration. Around the base are four figures. The pair nearest the camera are Neptune god of the sea and Amphitrite, one of his Nereids (sea nymphs or mermaids). Pictured before their marriage, he is gazing at her lovingly but she seems rather coy. To the left and right of their arms can be seen the arms of the corresponding pair similarly posed the other side. They are the lovers Acis and the Nereid Galatea. She rejected the advances of the one-eyed giant Polyphemus who killed Acis in a fit of jealousy. Above the figures, the fountain rises past two bowls to a mermaid holding a cornucopia (horn of plenty) out of which the water cascades (also symbolically). There were initial difficulties. The flow had to be carefully adjusted: too little produced a dismal effect and too much soaked passers-by. The water pressure was maintained by a steam pump under the Civil Court in St George's Hall. When a judge complained of interruptions to court proceedings because of 'subterranean pulsations' the power was changed to electricity.

Steble Fountain
with Neptune and
Amphitrite.

Philharmonic Hotel

Golden gates invite you inside the Philharmonic Hotel, conveniently placed for pre-concert patrons. The centrepiece of their Art Nouveau extravaganza of wrought iron and beaten copper is a plaque incorporating the Latin 'pacem amo' (I love peace) accompanied by unicorns, symbols of peace. The idealistic brewer Robert Cain wanted to beautify his public houses so that 'they would be an ornament to the town of his

Philharmonic Hotel entrance.

birth' and his brewery (see page 30) is also dignified by the motto and a harnessed unicorn. The hotel, opened in 1900, is at the other end of the spectrum from the Eagle in Blackstock Street. The opulent interior is a cornucopia of musical decoration and reminiscence. Over the doorway in the Grande Lounge is a bust of Apollo, Greek god of Music, and brackets supposably supporting the ceiling are in the form of fauns, mythical creatures with pan pipes hanging from their waists. Rooms are dedicated to the composers Brahms and Liszt. Even the men's urinals with their rose-coloured marble are a showpiece, although not on a detectable musical theme.

Calderstones Park

Once a Victorian man's garden, now a park for everyone. The mansion house was built in 93 acres of parkland by Joseph Need Walker, a lead shot manufacturer, in 1828. In 1875, the house and estate were acquired by Charles MacIver, co-founder of the Cunard Line, and bequeathed by his estate to the Liverpool Corporation in 1902. A similar but much later acquisition by the Corporation was Sudley House, home of the shipping magnate Alfred Holt, a Unitarian and founder of the Blue Funnel Line. The park boasts two pre-Liverpool relics, an oak tree, reputedly 1,000 years old, and the eponymous Calderstones, dolmens with curious carvings, 3,000 years older still.

Calderstones Park mansion and playground.

8
RELIGION

Congregational Church

Designed by the Corporation Surveyor, Joseph Franklin, the Congregational Church continued the Georgian tradition of neo-Classical architecture. It was opened in 1840, replacing an earlier chapel that had burnt down. Its dome, circular columned porch, and long line of double-banked windows emphasised by matching classical attached half columns make it one of the finest of the style to have survived (Franklin had competed with Elmes for the completion of St George's Hall in the same year). Welsh Congregationalists had built no fewer than six chapels in the town by 1860 but this congregation stemmed from a group of emigrants en voyage to America who were forced by the weather to return and elected to remain. The building has been converted into an arts centre. The modern arch is a reminder of the Chinese quarter on which it

Congregational
Church and
Chinese arch.

stands. Following the abolition of the slave trade, seafarers from China initially found a welcome stay for their cuisine and deckhand skills and were integrated into the town. Later, however, 'yellow' threatened 'white' labour. This led to the unemployment of Liverpudlian workers, growing prejudice and eventually violent hostility. The peace-loving Chinese maintained strong links with each other and their homeland.

St Francis Xavier's Church

Before this Catholic church was opened in 1848, it had been the subject of bitter controversy. The proposed Jesuit foundation was opposed by the congregation of St Anthony's Church who felt they would be deprived of income by a new nearby congregation. The Jesuits won, with safeguards for St Anthony's. Surrounded by streets labelled 'semi pauper', it was close to competing places of worship: an Anglican church, a 'dissenting chapel' and houses of 'scripture readers'. Designed to be the hub of the largest religious centre in the town for a congregation of 1,000, this proved insufficient and the Sodality Chapel was added in 1888. It was joined by an ever-expanding boys' school. From 1880 the poet Gerard Manley Hopkins spent time here as a parish priest working out from the church, but he was not happy and felt threatened when walking the streets. The predominantly Irish Catholics must have felt they were in another world as they entered the church that was full of light, colour and holiness. The stained-glass windows were especially beautiful and highly crafted (as illustrated). The columns are unusual, with their wide bases, narrow width and elaborate capitals giving the impression of cast-iron construction. In fact, they are of Drogheda limestone (appropriately an Irish connection) and designed to give good vision of the altar. The church is now a multi-denominational centre for Liverpool Hope University as part of their Creative Campus.

Christ the King window, St Francis Xavier's Church.

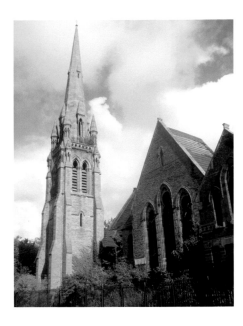

Welsh Presbyterian Church.

Welsh Presbyterian Church

The Welsh Presbyterian Church was the first of the magnificent and varied houses of worship that rose along Princes Road during the last part of the nineteenth century (in 1868). It also set a standard: the highest building in Liverpool (200 feet), overtaking St Nicholas' spire, a record it only held for one year until topped by the Municipal Buildings. It was joined in a flurry of building further down the road by the Trinity Presbyterian Church (late 1860s/70s), Mount Zion Methodist Chapel (1881), Princes Gate Baptist Chapel (1881) Methodist Church (1887) and the Anglican Church of All Saints (1882). The Welsh comprised 10 per cent of the population throughout the nineteenth century. Welsh chapels were important in cementing community spirit by encouraging both the Welsh and English languages, and the migrants were helped to adjust while preserving their identity. The Presbyterian church was part of the Parliament Fields development in the Princes Park area. It was managed by David Roberts, one of the many Welsh builders in the Liverpool area, and excluded public houses. The recent photograph shows that it is now in a perilous state of dilapidation.

St Margaret of Antioch

Built in 1869, St Margaret of Antioch is the oldest of the many Horsfall churches to have survived. The Horsfall family hailed from Huddersfield. Charles H. Horsfall, born there in 1776, sailed to Jamaica at the age of sixteen to make his fortune in the slave trade. When he died in 1846, his three sons built Christ Church, Great Homer Street, in honour of their father. Faithful to the Perpendicular Gothic style of the fifteenth century, it was destroyed along with its towering spire in the blitz of 1941.

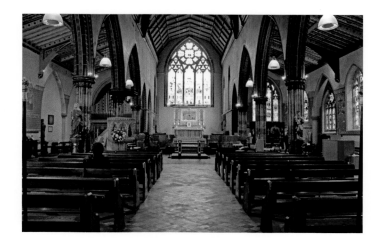

St Margaret of Antioch
interior.

St Margaret's was built by Robert, his stockbroker son, as an Anglo-Catholic centre for worship in Liverpool. Most munificent of all, Robert's son, H. Douglas Horsfield, and his mother built St Agnes, described later. Outside Liverpool, he also funded St Faith's, Crosby, and St Paul's, Stoneycroft, further out in Liverpool, and St Chad's theological college at Durham. As can be seen in the photo, the church is rich in the High Anglican tradition of great quality: painted ceilings, organ pipes and arch spandrels; patterned floor tiling; stained-glass windows in profusion; colourful statues; clustered shafts of Irish marbles with bands of alternating colours; and decorative gilded wood pulpit.

Greek Orthodox Church

The Greek Orthodox Church of St Nicholas was completed in 1870 in the presence of the Anglican Archbishops of Canterbury and York. On the edge of the Georgian

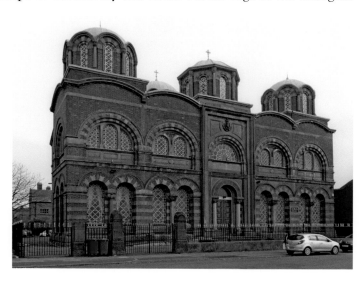

Greek Orthodox Church.

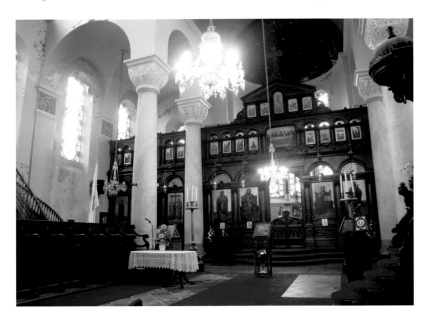

Greek Orthodox
Church interior.

quarter, it reflected the success of the Greek ship-owning and mercantile community. Initially they worshipped in a private house but then wished to have a worthier and convenient place of worship. Maybe they were spurred on in emulation of the achievements and magnificent places of worship recently constructed close by which advertised the success of other ethnic groups. If so, its magnificent exterior, an enlarged version of St Theodore's Church in Constantinople, rivalled the spire of the Welsh Presbyterian Church and the beautiful ornate facade of St Margaret of Antioch, and set a marker for the synagogue. It sported four domes on the roof set on drums in appropriate neo-Byzantine style with patterning of red brick and white stone especially over the window arches. The interior is relatively restrained but the white columns holding up the central dome have decorated capitals, the richly carved iconostasis as always in the Orthodox Church adds colour, and the chandelier spreads light. Pale blue on the walls, ceiling and stained glass of one of the drums give the illusion of sunlit skies in Greece.

St John the Baptist

This, the most sumptuous of all Liverpool churches, was built at the sole expense of Eliza Reide, the first incumbent's wife who also paid for the church school. It was designed in the early English Decorated Gothic style of the fourteenth century by the eminent architect George Frederick Bodley and no expense was spared in the lavish decoration. As can be seen overpage, the magnificent rood screen, the reredos behind the altar, the walls and the ceiling all glitter with gold, appropriately for its Anglo-Catholic worship. Only the columns of red and pale sandstone are unadorned. Both Morris & Co. and Byrne Jones produced more than one window apiece. Three years after its consecration

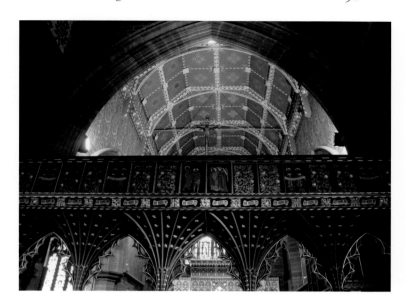

St John the Baptist
interior.

in 1871, the Public Worship Regulations Act was passed which laid down severe
penalties for liturgical innovators. This became a contentious issue when a 'low church'
bishop was appointed to the newly created diocese in 1880. The vicar of St Margaret's,
Toxteth, was imprisoned for seventeen days but the vicars of St John's managed to avoid
serious confrontation and also the attacks, verbal and physical, of militant protestants.

Synagogue

This dramatic view towards the rose window of the synagogue demonstrates the
growing opulence and confidence of the Jewish community in the late nineteenth

Synagogue interior.

century. The long-vaulted roof, the rich decoration of the roof, columns and key-shaped arch, together with the combination of Moorish and Gothic styles, make it one of the finest examples of Orientalism in Jewish architecture in the land. The church was opened in 1874 at the start of Princes Road, a major radial thoroughfare, in competition with recently completed neighbouring churches of distinction (Greek Orthodox Church and the high Anglican Church of St Margaret of Antioch). From the beginning of the century there had been Jewish immigrants, largely from Germany, of merchants, keepers of large shops and professional men. Their integration into the local community and influence was shown when one of their number was appointed mayor, but an antisemitic sermon in the council's church led to its withdrawal of favour. They were joined later on by refugees of poorer circumstances from Eastern Europe and European Russia. Although these had their own place of worship, they formed a strong bond with their wealthier brethren who helped them when in distress rather than rely on outside help. However, these new immigrants were often vilified by the press and public.

St Mary's Church, Walton

St Mary's Church, Walton-on-the-Hill, graced one of the 'lost' villages now submerged under the relentless onward tide of Liverpool during the nineteenth century. Then Bootle stopped its advance in the north by obtaining borough status in 1869 and saved other villages along the coast, but in 1895 Walton, along with West Derby, Wavertree and Toxteth, was incorporated into Liverpool. These and other villages, not as brave or far-seeing as Bootle, are thus now part of Liverpool's electorate, although some have still retained a strong identity. At that time Walton Hall, an early seventeenth-century

St Mary's Church, Walton.

manor house, was still standing. St Mary's, mentioned in the Domesday Book, predates Liverpool by over a century and was its parish church until 1699. The circular shape of its graveyard hints that it could be early medieval or even pre-Christian. An early eighteenth-century church was rebuilt in several stages until completed in 1843 as in the etching. Destroyed by bombing during the war, it has now been rebuilt, outwardly the same as before but the interior has been reordered.

Swedish Church

The Gustav Adolphs Kyrka 'Swedish Church' has been truly Scandinavian from the time it was built in 1884 to the present day. It was designed by W. D. Caroe, son of the Danish consul in Liverpool. Now it serves as a centre of worship and gathering for the Lutheran Swedish, Norwegian, Danish, Icelandic and Finnish churches. It was the first Swedish church built overseas and has provided not only a place for worship but also for protection and guidance with a reading room and postal facilities. The pyramid roof tops an octagonal centre which is reflected in the shape of the church inside. There are around thirty octagonal churches in Sweden but this is one of only four in this country. The stepped gables and timber spire (concave sided and lead covered) over the entrance are also Scandinavian in style. Swedes and Norwegians had a small but constant presence in Liverpool, but most of them while they were temporarily in residence on their migrations. The Norwegian Fishermen's Church adopted an early Victorian house in Southwood Road. Hengler, a Swede, founded a circus in Dale Street in 1858 with stables for fifty horses and ponies. It moved to much larger premises on West Derby Road in 1876 with accommodation for 4,500. It delighted audiences until the end of Victoria's reign in 1901.

Swedish Church.

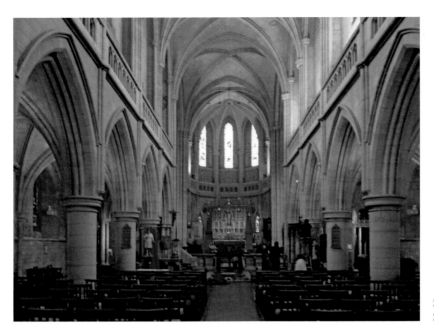

St Agnes and
St Pancras interior.

St Agnes' and St Pancras' Church

St Agnes' and St Pancras' Church looks like a cathedral in miniature – not surprisingly, as the architect was J. L. Pearson, the winner of the RIBA Gold Medal in 1880, who had designed Truro Cathedral and was supervising the work on its building. To create soaring Gothic arches in St Agnes, expensive stone was used inside with brick outside, the reverse of usual practice. It was another church funded by Douglas Horsfall (in 1885) and only the very best artists and materials were used. The organ case was created by Pearson himself (he also designed two for Westminster Abbey). Most of the windows are by C. E. Kempe, one of the leading Victorian stained-glass designers. Nathaniel Hitch, who worked on seven cathedrals in his time, sculpted the apse frieze in memory of Douglas's elder brother who died at the early age of thirty-seven. G. F. Bodley, the leading ecclesiastical architect in England, designed the screen and reredos of the south chapel. Norman Shaw, equally distinguished nationally in the domestic and secular field and architect of Albion House (page 31), designed the church hall and the vicarage (paid for by Douglas Horsfall's mother). The chapel of St Pancras was later absorbed by St Agnes but then demolished. Within the span of twenty years three other churches of note were built in the area: All Hallows in Allerton, famed for its fifteen Byrne Jones windows, the Roman Catholic Church of St Clare and the Unitarian Church (page 96).

Deaf and Dumb Institute

This typical faded glory illustrates a Victorian building at extreme risk of extinction. Outwardly, its octagonal tower resembling the Swedish church has stood the test of

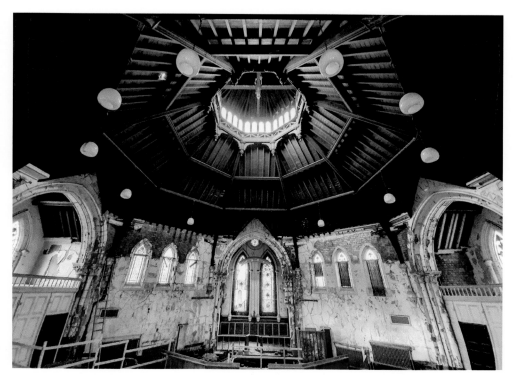

Deaf and Dumb Institute chapel.

time but inside decay is threatening its existence. The core of the Deaf and Dumb Institute, its chapel, shows the stepped seating that enabled the congregation to view the minister's sign language but broken stained-glass windows, peeling plaster and crumbling stonework betray the underlying neglect. Elsewhere sprouts attractive but destructive greenery amidst finely detailed rusting ironwork and mouldy murals. However, memorial tablets record better times: the institute was formally opened by HRH Princess Louise on 16 May 1887 (her mother's golden jubilee year); Robert Armour had started his thirty years' work as Missioner to the Deaf in 1883; and Juliana Clark, at the age of twenty-two in 1866, started teaching the deaf and dumb, service that lasted for fifty-six years. The institute was built following a fundraising campaign by the Liverpool Adult Deaf and Dumb Benevolent Society (to which Queen Victoria contributed £5) and operated from the same site for nearly 100 years before it was moved to West Derby. Since then, the Nigerian Igbo Association who took it over as a club were unable to maintain its upkeep, and it is now tenantless.

Ullet Road Unitarian Church

Unitarianism has a distinguished pedigree in the cultural life of Liverpool and its fight for social justice. William Roscoe campaigned for the abolition of slavery against

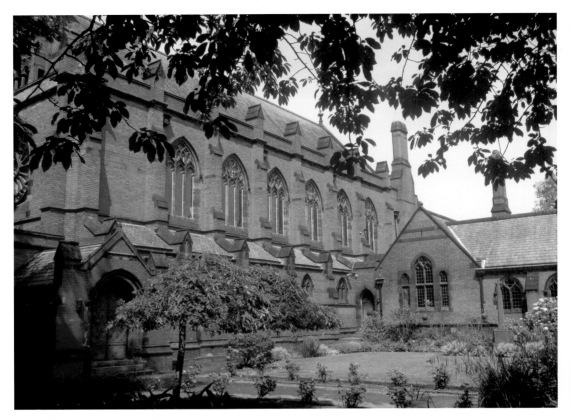

Ullet Road Unitarian Church.

strong opposition from politicians and merchants towards the end of the eighteenth century, supported by the Rathbone family who continued in the forefront of reform throughout the nineteenth century (and beyond). William Rathbone (the fifth of that name) was honoured with a statue in Sefton Park and his son William the Sixth with a statue in St John's Gardens (see pages 82-3). The Unitarians moved from their city centre church in Renshaw Street to Ullet Road in the superior residential area of Sefton Park in 1899. The windows in the church (on the left of the photograph) are for the most part from the William Morris workshop to designs by Sir Edward Byrne Jones. The beaten copper doors were designed by Richard Llewellyn Rathbone in an Art Nouveau style and the ornamentation of the choir stalls, reredos and stalls is also of the highest quality. The buildings to the right are grouped delightfully around a central garden starting with the vestry and library which are splendidly decorated with religious figures and symbolic representations of the triumph of virtue over vice. Finally, a cloister displaying monuments of famous Unitarians leads to the hall. The whole is one of the finest and most elaborate group of Nonconformist buildings in the country.